MW00629015

IMAGES
of America

COROLLA AND
THE CURRITUCK
OUTER BANKS

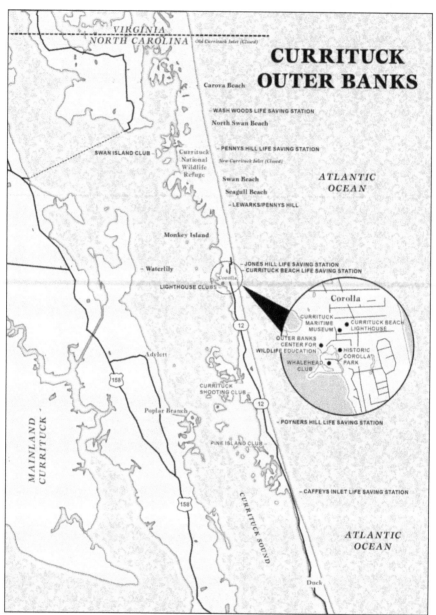

The Currituck Outer Banks begins just south of the Virginia border and joins a 200-mile-long barrier island chain. It has transformed from an isolated beach land wilderness to a vacation paradise. A string of lifesaving service stations and a lighthouse were built along this ribbon of sand to protect ships and human life from the underwater ocean shoals known as the "Graveyard of the Atlantic." (Coastal Impressions.)

ON THE COVER: A traveler in the late 1880s leaving the Currituck Sound and poling up to the landing would be delighted to come upon the Currituck Beach Lighthouse and the stately lighthouse keepers' dwelling. In the foreground, the shallow-water shove skiff was tied to a dock with a railway built for the purpose of transporting bricks to the lighthouse construction site. (Outer Banks History Center.)

IMAGES
of America

COROLLA AND
THE CURRITUCK
OUTER BANKS

R. Wayne Gray and Nancy Beach Gray

ARCADIA
PUBLISHING

Published by Arcadia Publishing
Charleston, South Carolina

Library of Congress Control Number: 2021937846

For all general information, please contact Arcadia Publishing:
Telephone 843-853-2070
Fax 843-853-0044
E-mail sales@arcadiapublishing.com
For customer service and orders:
Toll-Free 1-888-313-2665

Visit us on the Internet at www.arcadiapublishing.com

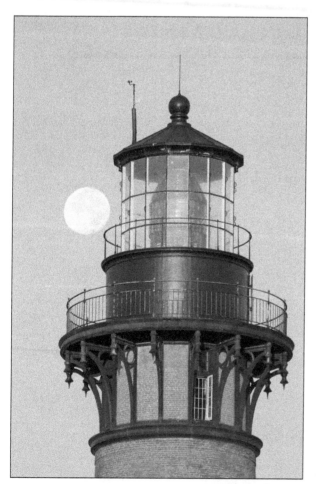

The redbrick Currituck Beach Lighthouse is a cherished sight for those at sea and those on land. It has stood over the village of Corolla since its completion in 1875, beaming a pattern of 3 seconds on and 17 seconds off. This well-timed shot not only shows the intricate ironwork of the structure, but also captures a streaming jet under a Carolina moon. (John Aylor.)

CONTENTS

ACKNOWLEDGMENTS

When the COVID-19 pandemic caused people to quarantine and museums, libraries, and history centers to close, our work on *Corolla and the Currituck Outer Banks* also came to an abrupt halt. After a few quiet weeks, we changed our mode of operation and redirected our efforts to locating folks who had visited or grown up in Corolla when it was secluded and remote. The harder road of research brought about richer rewards than those gained in cataloged archives. We can state unequivocally that many of the images in this book have never been published.

Scott Austin was the first Corolla resident to help. He trusted us to borrow over 100 photographs inherited from his uncle Norris Austin. Karen Scarborough Whitfield helped and also opened doors for us by introducing us to Carl and Janet Ross and Bobby Meade. Jami Lanier at the National Park Service, Stuart Parks at the Outer Banks History Center, Sharon Meade at the Outer Banks Center for Wildlife Education, and Jill Landen at the Whalehead Club found ways to assist us in the face of tight restrictions. Thanks go to Mitchell Bateman who introduced us to his childhood friend Joe Simons, who, in turn, introduced me to his cousin Harry Harrington. Sunny Briggs, Fran Mancuso, Barry Nelms, Barbara Haverty Pardue, Buddy and Edward Ponton, and the crew of Corolla Fire and Rescue graciously met us in person. As always, Meghan Agresto, Ladd Bayliss, Button Daniels, and Yulia Vozzhaeva were fantastic educators and facilitators. Marshall Cherry and Susan Joy Davis submitted to long, but invaluable, telephone interviews.

Our son Beach gave the book a final edit that his father would be proud of.

Finally, I would like to thank Arcadia Publishing. When Wayne passed away suddenly in August 2020, staff members whom I had never met reached out with their condolences. Our longtime editor, Caitrin Cunningham, said to take as much time as was needed to finish this book. Arcadia is not a faceless corporate entity, but a team of caring and committed professionals with hearts of gold.

Many images in this volume appear courtesy of coauthor R. Wayne Gray (RWG); the Outer Banks History Center (OBHC); the Outer Banks Center for Wildlife Education (OBCWE); and the National Park Service, Cape Hatteras National Seashore (NPS, CHNS).

INTRODUCTION

Corolla (pronounced kuh-RAH-luh) and the Currituck Outer Banks have risen to stardom in the last decades as a favorite tourist destination in North Carolina. The once extremely remote area of the Currituck Outer Banks still requires a circuitous route with only one roadway in. It is a narrow strand of beach only about 25 miles long and less than a mile wide. It stretches from the Virginia line down to just north of the town of Duck, North Carolina.

Indigenous people came from the mainland to hunt and fish before European settlement. The natives called the area Carotank, meaning "land of the wild goose." In 1566, Spanish explorers claimed the land for Spain. Years later, Francis Yeardley declared the land to be England's. Centuries later, a number of small settlements, usually around lifesaving service stations, grew up along this stretch of beach. The tiny hamlet of Corolla sits in the shadow of the Currituck Beach Lighthouse. It is the only remaining village on the North Banks.

A few tenacious settlers began inhabiting this isolated terrain year-round in the late 1600s. These pioneers' livelihoods consisted of small-scale farming, fishing, raising livestock, drift whale processing, and shipwreck salvaging. Activity increased as Old Currituck Inlet opened about 1650, and trading ships began entering the working port. A new Currituck Inlet opened in 1713, just a few years before the old inlet would shoal and close. The area was protected from American Revolutionary wartime activity by underwater sandbars along the coast. British attempts to gain a foothold in the area often ended in wrecked ships with the cargo going to the locals.

Wild herds of horses inhabited the Currituck Outer Banks by the 1700s. They most likely swam ashore from Spanish and English shipwrecks or escaped exploration parties. However, herds did not roam free for long as opportunistic locals corralled and tamed them for two primary purposes, herding cattle and transportation.

In 1828, New Currituck Inlet closed, and the Currituck Sound was transformed from a saltwater to a freshwater ecosystem. This alteration caused the growth of different types vegetation that drew massive numbers of ducks and geese. As a result, a new era of waterfowl hunting dawned, and with it came new ways to supplement the locals' previously meager subsistence. Boatbuilding, decoy making, and jobs as hunting guides brought income to hard workers. Hunt clubs began to be built as rich Northern sportsmen came in droves for a premier shooting experience. In 1857, the Currituck Shooting Club was established. Dozens of other hunting clubs soon followed suit, with the owners buying thousands of acres each for their shooting fraternities. The most ornate one of all, Corolla Island, now known as the Whalehead Club, is still in the center of Corolla village.

Commercial or market wildfowl hunting was dominant from the Civil War until the 1920s, and thousands of slaughtered ducks and geese were shipped primarily to Philadelphia, Baltimore, and New York. The opening of the Albemarle and Chesapeake Canal in 1859 provided a fast shipping lane for hunters sending their fowl to Northern food markets.

All the while, inlets periodically opened and closed, changing the lives and livelihoods of the North Bankers. The many hard nor'easters and storms that continuously modified geography were a constant and expected part of living on a barrier sandbar.

As our nation grew and water transportation increased, so did a disturbing trend of shipwrecks. Because of the great loss of life, the federal government initiated plans to build a series of lifesaving stations and lighthouses. In 1874, the first US lifesaving station in this area was built at Jones Hill north of what is now Corolla. In 1875, the Currituck Beach Lighthouse was completed. In 1876, a large Victorian duplex was built as quarters for three keepers and their families. The lighthouse with its flashing beam of light is still an active aid to navigation, maintained by the US Coast Guard.

When Corolla's post office was established in 1895, the US Post Office Department asked for a recommendation of possible names for the new facility in a locale already known by many names: Whales Head, Jones Hill, and Currituck Beach. A totally new submission, Corolla, was entered after a schoolteacher, who was listening to names being suggested, picked a wild violet and commented that the inner circle of petals is known as a corolla. He thought the tiny village was a beautiful center to the surrounding area. Postal officials also agreed.

The local population funded the construction of an interdenominational church around 1885. The Corolla Chapel, a focal point of the community for decades, has been revived and expanded in modern times after a period of disuse.

About 1895, a public school was built. Up until that period, there had been as many as three private schools, with one exclusively for the children whose fathers were in the local lifesaving service. Today, the old public school has been refurbished into Water's Edge Village School, a charter school and an integral part of the community.

Currituck Outer Bankers saw the horrors of war when U-boats actively sunk merchant ships off the coast of North Carolina in both world wars. Locals, who were already used to doing without, experienced additional hardship with severe rising prices and shortages of daily necessities. During those decades, many residents relocated to the Tidewater Region of Virginia for steady employment in shipyards.

The population decreased, and by 1970, only 15 people lived in Corolla. Outside investors with the foresight to see opportunity began buying up big tracts of land. The state highway ended at Duck, and the need for a paved road northward became essential for land developers to implement their strategies. When the road to Corolla was constructed in 1984, real estate prices went sky high and homes and shopping centers were built at a rapid rate. Tremendous luxury vacation rental houses were new to the scene. They featured amenities that made vacationers feel like they were living the life of the rich and famous if only for a week.

A small band of preservationists and its leader, a descendant of a lighthouse keeper, were able to get a deed to the Currituck Beach Lighthouse property. They expertly restored the keepers' house and outbuildings. They continue to repair and maintain the lighthouse. Currituck County also got involved in preservation when it bought the beleaguered Whalehead Club, bringing the architectural showpiece back to life and establishing Currituck Heritage Park next to the lighthouse. At the urging of locals who wanted to see their waterfowling history preserved and displayed, the North Carolina Wildlife Resources Commission established the Outer Banks Center for Wildlife Education. The most recent addition to the historic loop, the Currituck Maritime Museum, exhibits the wooden watercraft of the region and honors the humble masters who built them.

The old Corolla can still be found where it began around the lighthouse. A totally new Corolla, though, has sprung up out of a beach land wilderness.

One

A COLONIAL FOOTHOLD

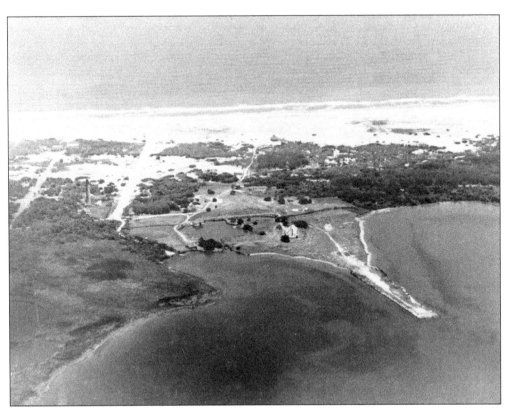

With the constant and aggressive elemental battery of water, wind, and sand, it is not difficult to imagine the Currituck Outer Banks in predevelopment days even before this 1940s-era shot. The land was mostly nonarable wilderness, considered good only for raising livestock that grazed on marsh grass and fended for themselves in an unfenced territory. (Norris and Scott Austin.)

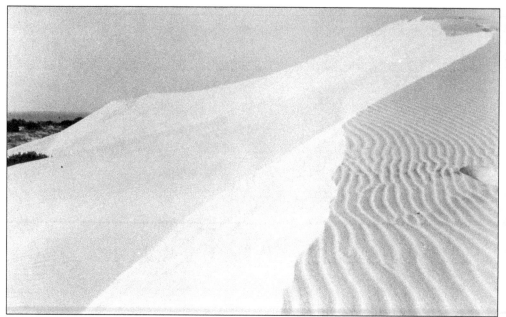

Winds blowing back and forth swept up towering dunes, some of the highest on the East Coast. Migrating dunes swallowed up whatever was in the way from ancient cedar forests to man-made structures. A National Park Service employee took this photograph of a colossal sand dune in 1955 when information was being gathered about creating a national park, an idea that county officials protested. (NPS, CHNS.)

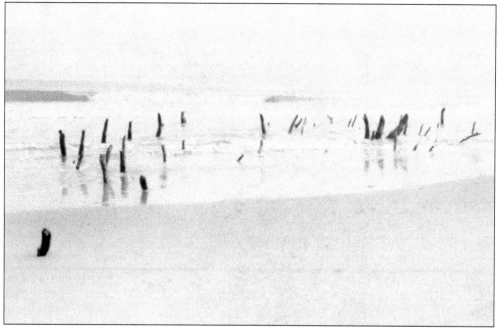

This 1938 photograph of cedar stumps in the breakers is ghostly evidence of a shoreline that was situated farther to the east. As dunes migrated west, they left behind the remains of trees that were suffocated when first covered in sand. The area, Wash Woods, shows the relentless trek that the Currituck Outer Banks continues to make westward. (NPS, CHNS.)

Pedro de Coronas of Spain landed on Currituck Beach in 1566 after he was blown off course exploring Chesapeake Bay. His small party entered Currituck Sound through the old inlet and explored about 20 miles inland for several days. They erected a cross on the beach and claimed the land for the king of Spain. The king's goal was to plant Catholic mission stations northward along the coast. (NPS, CHNS.)

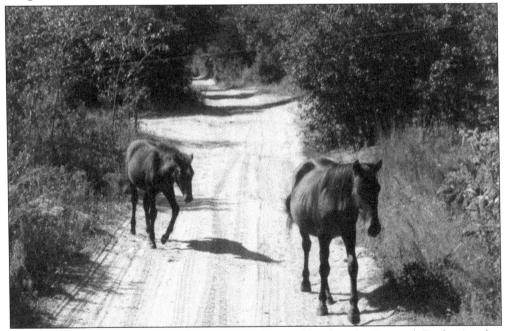

One theory has it that shipwrecked horses swam ashore and lived on the Currituck Banks. Another account is that mustangs escaped the Spanish exploration party and got left behind. Either way, Spanish explorers did not return to this stretch of sand and marsh. Spain abandoned plans for settling this far north and sought gold and silver elsewhere. (RWG.)

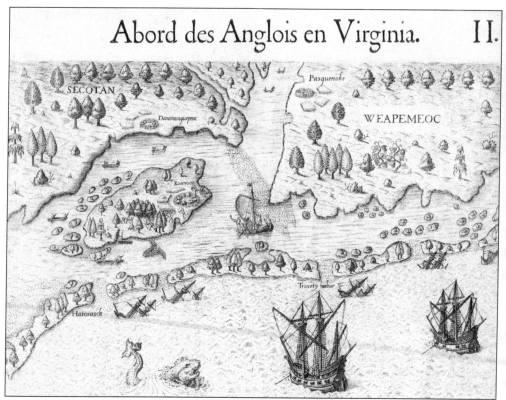

The Currituck Banks appear on the right side of this 1590 map by cartographer John White. The map shows ships that floundered while attempting passage to the mainland through surprisingly shallow inlets. Later, in 1653, a Virginia-born English explorer, Francis Yeardley, sponsored a discovery trip south to "Carolana" and claimed the Currituck Banks for England. (OBHC.)

A decade later, King Charles II portioned out Carolina lands to courtiers who had helped him restore the English monarchy. The lords proprietors, as they were called, were given vast landholdings that they hoped would pay big returns. However, settlers were already drifting down from Virginia and were buying land from the Poteskeet natives rather than from the proprietors. This 1938 photograph reflects a harsh environment those early settlers may have encountered. (NPS, CHNS.)

Today's North Carolina–Virginia border extends into the breakers. American-born William Byrd II was an educated, elected legislator in the Virginia House of Burgesses. He and his company of well-provisioned woodsmen, laborers, surveyors, and fellow commissioners agreed to meet a party from North Carolina "at Coratuck" on March 5, 1728, to resolve the North Carolina–Virginia boundary controversy. (Edward Ponton.)

The commissioners from North Carolina and Virginia debated where the dividing line should be. Tradition had it at the north shore of the Old Currituck Inlet, but the Carolinians argued that the spit of sand shifted constantly, and the inlet had retreated. For the sake of peace, they fixed a border 200 yards north of the inlet and drove a cedar post deep in the sand. Centuries later, a monument marks the historic spot. (Edward Ponton.)

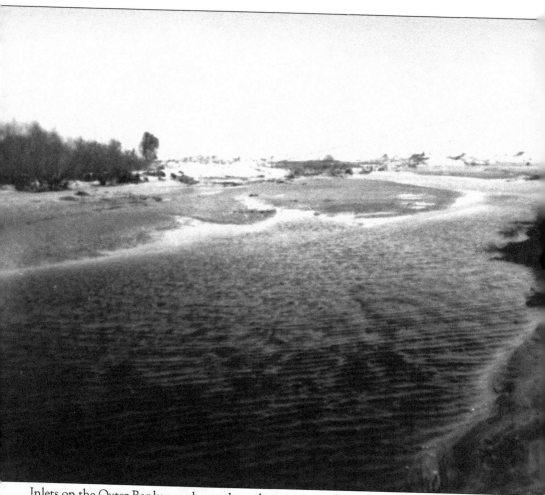

Inlets on the Outer Banks are places where the ocean waters cut a path westward across land to join sound waters. They range from a shallow rivulet of a few inches to a deep slash of many feet. This photograph shows an inlet north of Corolla cut by the Ash Wednesday Storm in March 1962. It proved to be temporary; nonetheless, when the ocean determines to permanently break through a weak spot on the shore, the efforts of mankind can do little to stop it. Geologists claim that there have been numerous inlets on the Northern Banks over the last four centuries, resulting in a string of islands. With the closing of those once established waterways, the Currituck Outer Banks is now part of a peninsula that originates at Cape Henry in Virginia Beach and stretches all the way down to Oregon Inlet. Old Currituck Inlet, which played a major part in the 1728 North Carolina–Virginia boundary dispute, confused the commissioners by moving and shoaling up. It would close entirely in 1731. Traders and watermen were pleased that a New Currituck Inlet opened in 1713. It was a 10-foot-deep passageway for over 100 years. (Barbara Haverty Pardue.)

Around 1714, Currituck Banks inhabitants told the Poteskeet tribe that they would break their guns if they continued to hunt their usual grounds. The tribesmen took their case to the North Carolina Council, which ruled in their favor and ordered "no interference with the Poteskeets." No doubt, the Poteskeets were supplementing their diets with wildfowl, like Norris Austin did in the late 1950s. (Norris and Scott Austin.)

Libby Tillett (left) and Jewel Scarborough (right) delighted in showing off a corrugated metal fishing shack in the 1950s. Since colonial times, people have erected primitive shelters on the beach that would not be a great loss if destroyed by weather or tide. Since many of the early settlers were running from the law, their resources were limited and their interest was fleeting. (Karen Scarborough Whitfield.)

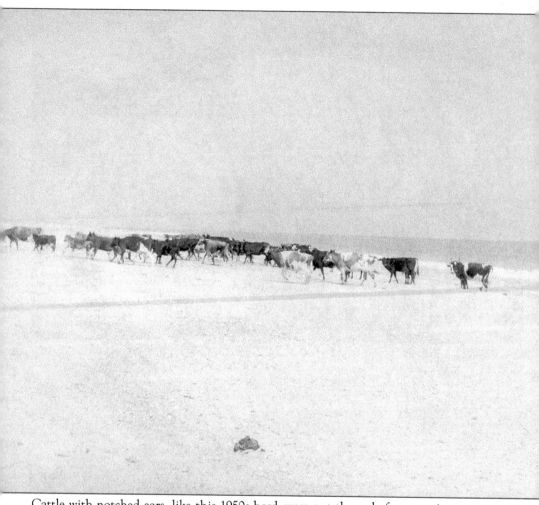

Cattle with notched ears, like this 1950s herd, were not the only free roaming creatures on the rustic banks. Commissioner William Byrd II comically described some odd individuals he observed while settling the boundary dispute in 1728. He wrote the following: "Not far from the inlet, dwelt a marooner, that modestly called himself a hermit, though he forfeited that name by suffering a wanton female to cohabit with him. His habitation was a bower, covered with bark after the Indian fashion, which in that mild situation protected him pretty well from the weather. Like the ravens, he neither ploughed nor sowed, but subsisted chiefly upon oysters, which his handmaid made a shift to gather from the adjacent rocks. Sometimes, too, for change of diet, he sent her to drive up the neighbour's cows, to moisten their mouths with a little milk. But as for raiment, he depended mostly upon his length of beard, and she upon her length of hair, part of which she brought decently forward, and the rest dangled behind quite down to her rump, like one of Herodotus' East Indian pigmies. Thus did these wretches live in a dirty state of nature, and were mere Adamites, innocence only excepted." (Lisa Griggs, Aycock Brown Collection.)

Pirates operated freely off the North Carolina banks during their golden age from 1713 to 1718. Pirate ships were known to pass through the New Currituck Inlet to reach the south end of neighboring Knotts Island, where there was a tavern reputed to be a hangout for pirates and thieves. Runaway slaves, criminals, and nefarious characters were said to live in any available beach shelter. (Barbara Haverty Pardue.)

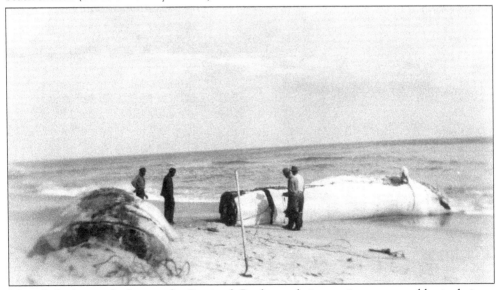

This whale that washed up on the Currituck Banks was being cut into manageable-sized pieces for disposal by burial. Men of an earlier era would see the whale as a godsend, set up an operation directly on the beach, and render down the fat to make valuable whale oil. As early as the 1660s, barrels of American whale oil were being shipped to London out of nearby Colington Island. (The Whalehead Club.)

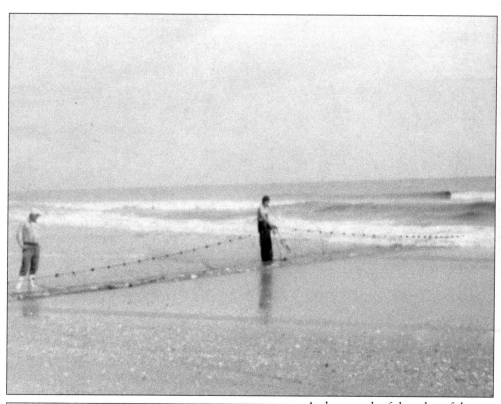

A photograph of these hopeful fishermen in the 1960s is a reminder that since the barrier strand is so narrow, early inhabitants could set a beach seine net in the ocean, get oysters from sound waters, and tend a small garden near a wooded thicket all in one day. A shallow freshwater well could be driven almost anywhere due to underground pockets of collected rainwater. (Bobby Meade.)

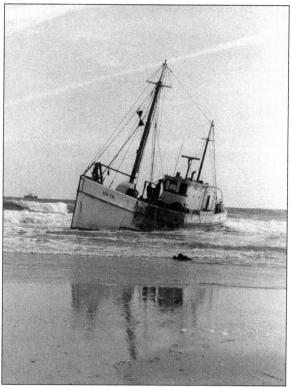

In earlier times, before the wreck of the trawler *Sea Pal* in the late 1960s, Bankers were known to strip a stranded vessel down to the ribs before shipping company owners could arrange to have it salvaged. Lumber and timbers were used to build homes. Stocks of provisions fed families. Businessmen saw wrecking as pillage, while Bankers saw it as opportunity. (Norris and Scott Austin.)

Jones Hill, which was bulldozed down to make a subdivision, may have provided a good lookout spot for watchmen during the Revolutionary War. Although most encounters with redcoats in North Carolina took place south of Currituck, Bankers stood at the ready to stop enemies from raiding shipping vessels and foraging parties from stealing cattle. (Norris and Scott Austin.)

Evergreen live oaks may have afforded cover for armed companies. It is doubtful that the Bankers turned American patriots had much pay, provisions, arms, or equipment provided them, but they did benefit from spoils left by fleeing raiders and shipwrecked enemy vessels. American Revolutionary colonel Samuel Jarvis bestowed the name "Currituck Liberty Plains" on the area during the attacks. (OBHC.)

Albemarle County was divided into four precincts in 1670 due to its vast size and small population. One precinct was named Currituck, from the Native American word Carotank, meaning "land of the wild geese." Currituck was a difficult land for people to inhabit, in part because of insects, muddy marshes, and navigationally shallow waters. Resourcefulness and physical stamina were required of its residents. (Norris and Scott Austin.)

Wiley and Fay Jones were not the only ones to ride a black Banker pony. In 1776, young Betsy Dowdy heard that American Revolutionary general William Skinner and his militia were needed to help fight against the British in Great Bridge, Virginia. She resolved to get the message to the patriots, called her Banker pony, Black Bess, in from the marsh, forded the Currituck Sound, and rode all night to Perquimans by way of the Old Swamp Road. (Carl Ross.)

Generations of Bankers, like these girls shown on a postcard with the caption, "Enjoying a quieter time in Old Corolla," have read the story of Betsy Dowdy. Although it seems like a tall tale, research reveals that General Skinner and a company of North Carolina militia did arrive on December 4, 1776, in time to defend Great Bridge. The patriots helped to run Britain's Lord Dunmore out of Norfolk. (Norris and Scott Austin.)

Some have speculated that the teenage girl's ride would have been impossible with any ordinary horse but perhaps probable with a hardy Banker pony. When tamed, Banker ponies were strong, swift, intelligent, and considered a prized possession by anyone who owned them. In the photograph, Pell and Lela Austin's Banker pony was unfazed by their truck. (Bobby Meade.)

The British landed on the Currituck Outer Banks again during the War of 1812. They passed through the New Currituck Inlet, captured or burned vessels, and chased and fired upon oyster boats and canoes. An article in the *Raleigh Register* stated that "the greatest alarm and confusion prevailed," which was radically different from the peaceful scene of the Sanderlin home cookhouse in the 1940s. (Norris and Scott Austin.)

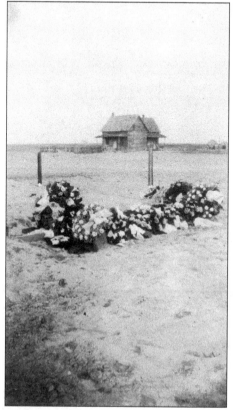

This grave on the beach signifies the transition of one generation to the next. The community gradually transformed from a hideaway for outlaws and thieves to a home for the independent and faithful. The Bankers' vulnerability to the whims of nature inspired a faith in God to provide and protect. (OBCWE, Steven Meade Collection.)

Two

Guns Blazing
in Open Spaces

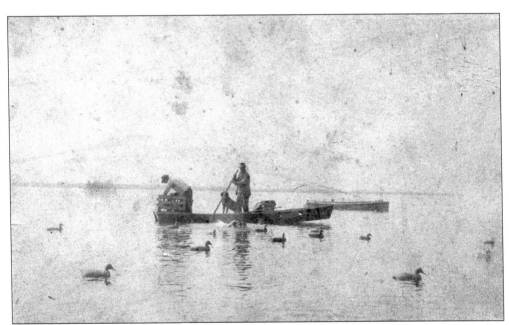

Local hunters lowered live geese from a shove skiff into the Currituck Sound amid wooden decoys. Named Judas geese because of their betrayal, the live decoys were used to call in wild flocks from overhead flight. Before retreating to blinds, hunters tied the geese to posts by one foot. When the shooting started, Judas geese ducked and swam as far away as their restrictive lines allowed. (Carl Ross.)

Today's Canada geese in Corolla have little to fear from humans, but it was a different story two centuries ago. The New Currituck Inlet shoaled up and closed in 1828, just two years after Caffeys Inlet, about 20 miles south, waned. With no salty seawater coming in from the ocean, the sound waters became increasingly fresh. Journalist T. Edward Nickens wrote the following: "Oyster beds disappeared, and saltwater fish were wiped out. In their place, however, came enormous numbers of perch, bass, eels, and underwater plains of freshwater plants relished by waterfowl. The Currituck Sound bottom, reported Alexander Hunter in 1892, was 'one mass of wild celery.' Untold numbers of wintering ducks, geese, and swans piled into the shallow waters—black ducks, pintails, widgeon and teal packing into open marsh ponds, while diving ducks such as canvasbacks, redheads and scaup rafted up by the thousands on the windswept open waters. Stories of duck flocks that darkened the sky are not uncommon, nor far off the mark." Hope and a chance at a better life for the people descended upon Currituck like the numerous flying birds. (John Aylor.)

Currituck was economically poor, especially compared to the agriculturally rich counties of Bertie, Perquimans, and Pasquotank. Opportunities to earn cash suddenly appeared thanks to the mass influx of waterfowl. Market hunters filled orders for fowl to satisfy palates of that era that preferred gamey tastes. Demand for guides and boatbuilders increased. Carving decoys, oars, and shove poles became cottage industries. (Norris and Scott Austin.)

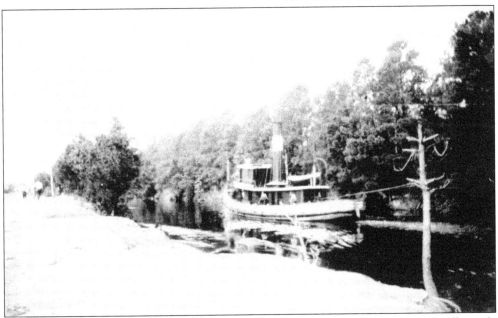

Norfolk merchant Marshall Parks perfectly timed the building of his toll waterway, the Albemarle and Chesapeake Canal. Completed in 1859, this marvel provided a route for fresh wildfowl to reach the train depot in Norfolk where it was moved on to eager consumers in Philadelphia, Baltimore, and New York. This little steamer could carry fowl-packed barrels or pull smaller boats filled with ice and fowl. (Norris and Scott Austin.)

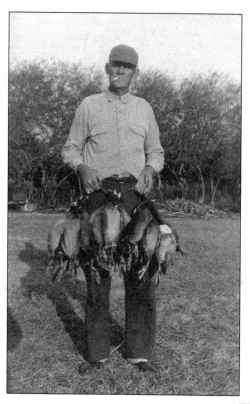

Pell Austin, pictured with his day's take, hunted within enforced regulations, but the early game hunters took all they could. Virginia newspaper editor Edmund Ruffin visited Currituck County in the late 1850s and wrote about one farmer who hired 30 gunners to hunt his farm. They used a ton of gunpowder, four tons of lead shot, and 46,000 percussion caps. And that was just one shoreline location. (Bobby Meade.)

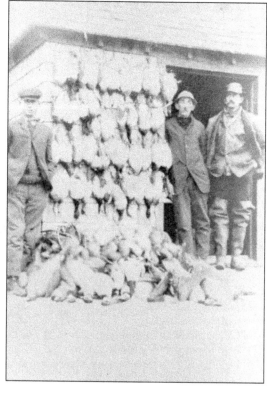

Unlike this photo opportunity with birds hanging outside, market gunners hung their fowl up in game barns overnight to cool down before shipping to East Coast cities. The North Carolina coastal region benefited from an efficient transportation system of railway and steamship lines. Perishable food could arrive in Washington, DC, and Baltimore on the first morning after shipment. (Norris and Scott Austin.)

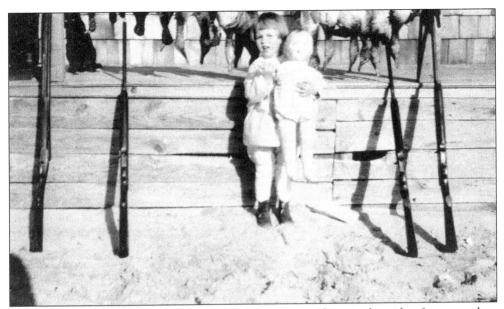

This little girl shows off her baby doll, most likely a catalog purchase, in the midst of commonplace guns and downed ducks. Commercial gunners hunted in blinds and batteries, also known as sinkboxes. A sinkbox was a submerged coffin-shaped enclosure stabilized by a floating platform. When lying prostrate in the box out in the water, the hunter would be undetected until sitting up to shoot. (Norris and Scott Austin.)

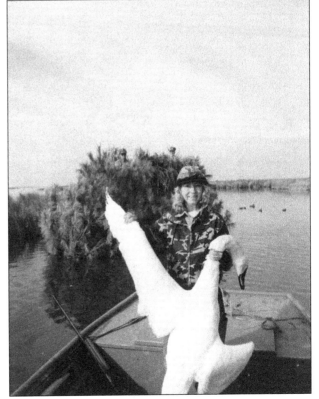

Lynn Scarborough proudly showed off her swan in the 1980s. In addition to being crack shots, commercial gunners took every advantage by using sinkboxes, cannon-like punt guns, and methods of funneling ducks. Their deadly success brought about the ire of well-to-do sportsmen, who became acquainted with the area in the late 1800s and brought with them a conservation mentality. (Karen Scarborough Whitfield.)

Some sportsmen stayed in the homes of local guides hired to take them to premier shooting spots. The guide's family members often had to give up the best bedroom, and women had to cook robust meals. An enterprising guide, L.R. White, built this hotel for hunters in 1894 at the site of the Old Currituck Inlet. White, nicknamed "the Democrat," also had the largest cattle operation on the Currituck Outer Banks. (Barbara Haverty Pardue.)

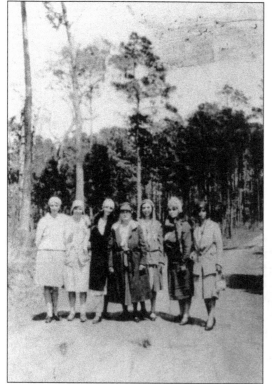

L.R. and Maggie White had 15 children in 26 years. Chic daughters pose with their mother in 1927. They are, from left to right, Marguerite Raynor, Dona Williams, Lucy Beasley, Maggie Baxter Cowell White, Addie Toler, Chloe Sanderson, and Bessie Sessoms. Pres. Grover Cleveland stayed at the L.R. White Hotel in 1895 and bagged yellowshanks and plovers. (Barbara Haverty Pardue.)

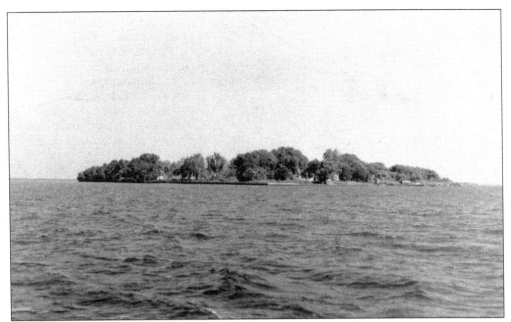

Many locals succumbed to the temptation to sell their land to well-off sportsmen. Shown here, Monkey Island, originally held by the Pamunkey tribe, changed hands many times, but it is now part of the Currituck National Wildlife Refuge. In contrast, the descendants of L.R. and Maggie White have managed to retain 485 acres, part of an original lords proprietors' land grant. (Norris and Scott Austin.)

Here, an experienced guide sits on the steps of the Currituck Shooting Club prior to 1900. In 1908, Alexander Hunter recorded the following in *The Huntsman in the South*: "These sand-dwellers . . . dislike steady work, and leave that to their wives and daughters, who slave from daybreak until dark. The men can pole a boat all day, and suffer hardships uncomplainingly, but when not on a hunting trip they simply lounge." (Carl Ross.)

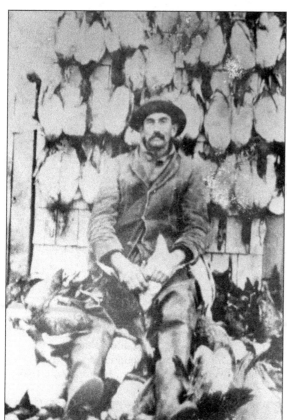

Guide Benjamin Lafayette Etheridge is seen perched on a mound of ducks and geese. Corolla native Norris Austin recalled that the hunting clubs baited fowl with grain, which was brought across the sound on a barge. He reflected, "The northerners wanted the fowl stored until it was tainted a little bit. They didn't really know how to eat ducks and geese—they ate them half raw." (Norris and Scott Austin.)

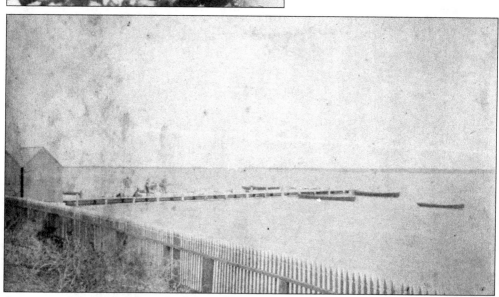

Aristocratic New Yorkers brought their yacht *Anonyona* up the Currituck Sound in 1870. They anchored off Crow Island, but the receding tide left them high and dry. Unable to continue their trip, they went hunting in the area and later bought the island, marshlands, and a farmhouse. The complex was later named the Swan Island Club and brought up to better standards, including this pier. (NC State Archives.)

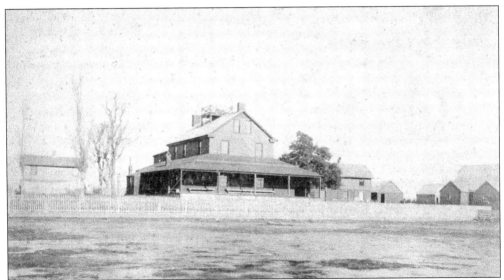

Harvard-educated club members built the almost square Swan Island Clubhouse in 1913–1914 after losing the yacht, the farmhouse, and a lodge to fires. They housed marsh guards in two-room shanties and hired them to protect the game lands from poachers. Guards also manned a huge rifle on a swiveling pivot in the rooftop crow's nest to send a whizzing warning shot near any violators. (NC State Archives.)

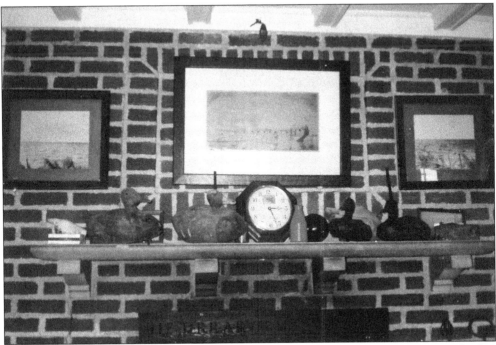

Inside the Swan Island Clubhouse, a mantle displayed wooden decoys that are now valued as collectors' items but were once communally owned and stored in barns by the hundreds. In the Prohibition era, members hid their liquor behind a secret panel in the clubroom. Each bedroom had an iron heater that an attentive guide lit on hunt days before the member woke up. (Barbara Haverty Pardue.)

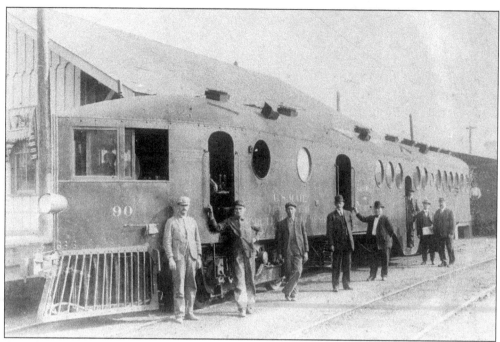

Once hunters made it to Norfolk in 1910, they could hop on this little gasoline-powered train, the *Scooter*, for a quick ride to Munden Point in Virginia Beach. The club yacht picked up Swan Island Club members there for the last leg of the journey. When Currituck Sound was frozen over, they came down the ocean shoreline by horse and cart and crossed the sound in skiffs converted to sleds. (Virginia Beach Public Library, Edgar Brown Collection.)

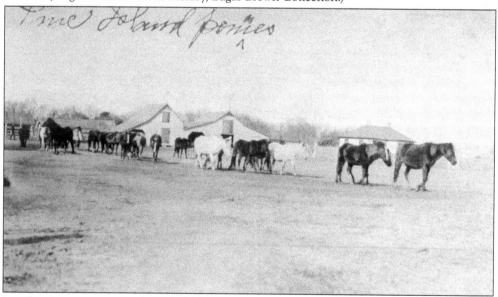

Josephus Baum was said to have killed more fowl than any commercial gunner. He inherited a massive tract of sea-to-sound land in 1850 that is known today as Pine Island. There he built a hunting lodge, Palmers Club, and managed herds of cattle and horses for 42 years. His son Julian left a medical practice and farm in Virginia and moved his wife and children to the remote beach. (The Whalehead Club.)

The photograph depicts a mostly self-sufficient complex at Pine Island where the Baum family lived and rented accommodations to guests and guides. Outbuildings not shown in this photograph included a barn, washhouse, smokehouse, poultry houses, and boathouses. The Baum men were such good hunters that some days duck was served for all three meals. (Carl Ross.)

Dr. Julian Baum's wife, Lillie, kept notes of daily life at Pine Island. She chronicled hog killings, the arrival of sheep shearers, setting nets in the ocean, and day trips down to Bank Woods (present-day Duck). The family retrieved mail and catalog deliveries from Poplar Branch across the sound. Although Julian did not seek to practice medicine, he would come to the aid of friends and neighbors if needed. (Carl Ross.)

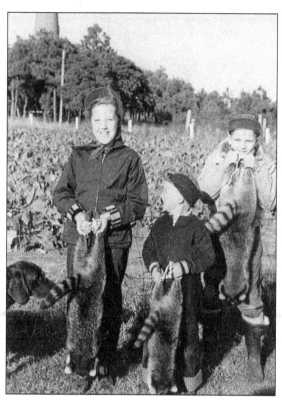

In addition to daily chores and upkeep, the Baums undertook any activity that would bring in extra revenue. In 1907, muskrat and raccoon hides from winter trapping brought in $36. Fifty years later, from right to left, Meta and Karl Eippert and Joe Simons Jr. display the spoils of a raccoon hunt. In this instance, their landlord wanted to thin out predators that would eat waterfowl eggs and hatchlings. (Joe Simons.)

In 1910, the Baum family sold Pine Island to a group of Boston sportsmen for $60,000. Dr. Baum had planned on returning to medicine, but the new owners made him an offer to stay on as superintendent. In 1913, a fire started in the kitchen of the clubhouse, shown here, and quickly spread since the buildings were packed so closely together. There was no stopping it. (Carl Ross.)

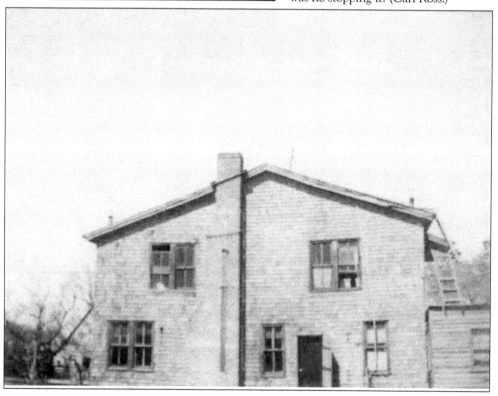

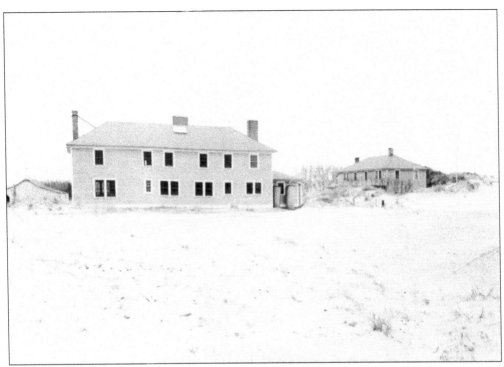

The owners of Pine Island wasted no time in getting a new club built in just seven months. Boarding was found for employees and guest hunters, and the Baums lived in one of the guard shacks. In this 1955 shot, the photographer unfortunately caught the rear, rather than the more architecturally interesting front, of the Pine Island Clubhouse. The guides' quarters are on the right. (NPS, CHNS.)

Carl P. White posed at a mainland Currituck home in 1923 with cousins Nellie (left) and Lucy (center). He held the position of superintendent of the Pine Island Club for 38 years after Austin Barney of Farmington, Connecticut, bought it. Barney purchased the property during the Depression for only $25,000. When Barney's heirs were ready to sell, White was instrumental in contacting the next owner, Earl Slick. (Carl Ross.)

Pine Island superintendent Carl P. White was highly esteemed in the local hunting scene. New club owner Earl Slick was a pioneer in a nationwide airfreight business and an investor in oil exploration. After enjoying Pine Island for many years, Slick donated 3,400 sound-side acres and buildings to the National Audubon Society in a "slick" deal that allowed him to keep the oceanfront land and write off the taxes. (Carl Ross.)

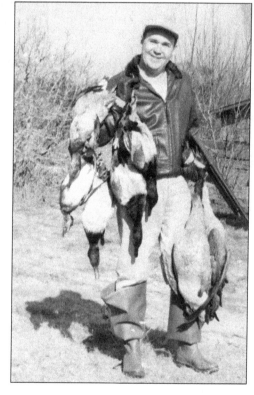

Carl P. White's son-in-law Joseph Alex Ross came to Poplar Branch to teach mathematics in a school built in part with money given by Northern gunners. Visiting sportsmen saw a real need for education in the county and responded generously. This 1950s photograph shows Ross's enthusiasm for hunting. When asked why he married a local girl, he joked, "For the hunting, son!" (Carl Ross.)

John Poyner was nicknamed the "granddaddy" of the hunting clubs. He served as the fourth (out of just six) superintendent of the historic Currituck Shooting Club from 1909 until his retirement in 1960. The club was organized like a corporation with 21 stockholders, who employed a superintendent to manage the property, hire guides, purchase equipment, and keep the accounts. (Bob Furr.)

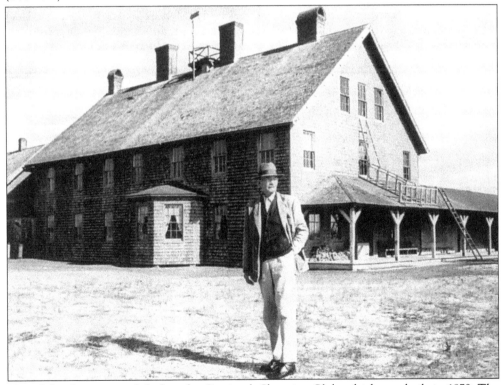

Here, John Poyner stands before the Currituck Shooting Club, which was built in 1879. The mostly heart pine and cypress lumber was precut in New York and sent on a barge to its location just west of the fifth tee of the present-day Currituck Golf Course. At one time, it was America's second-oldest continuously operating gun club (established in 1857) and was listed in the National Register of Historic Places. (Carl Ross.)

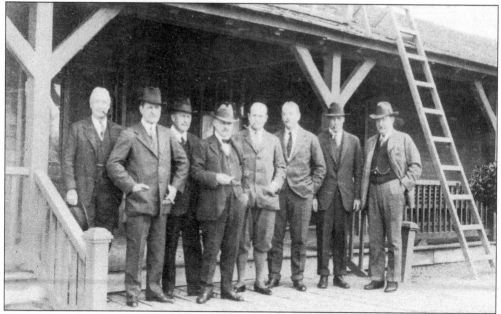

The membership roster read like the *New York Times* society page. Gathered on the Currituck Shooting Club walkway in 1920 are, from left to right, J.P. Morgan Jr., Arthur Iselin, Frederick Brewster, Oliver Jennings, three unidentified men, and J. Sanford Barns. Not pictured, W.K. Vanderbilt was also a charter member. The wealthy men were industrialists, business tycoons, and politicians. (Bob Furr.)

Although social classes remained well defined, out in the marsh respectful friendships were formed between local guides and Northern club members. On the Currituck Shooting Club steps are, from left to right, an unidentified man, John Carlo Parker of Aydlett, Lloyd Baum of Poplar Branch, and John Poyner. Baum was guide to Henry O. Havemeyer, a sugar refiner and philanthropist. (Bob Furr.)

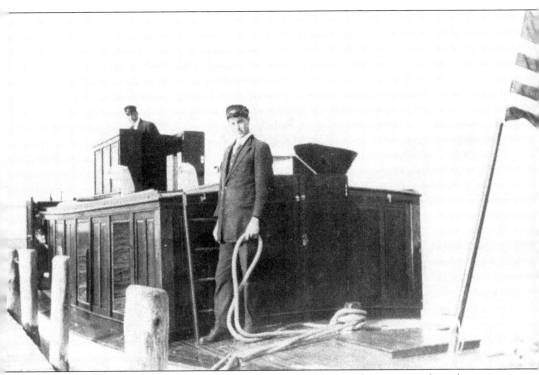

Christened the *Cygnet*, the Currituck Shooting Club's 55-foot-long luxury motor launch was very much the graceful young swan. This sharp crew consisted of, from left to right, engineer Harry Halyburton of New London, Connecticut; Captain Kent of Swan Island, Maine; and Henry Twiford of Poplar Branch, North Carolina. With only a 24-inch draft, it was perfectly suited to transport hunters across the shallow sound from Van Slycks landing to the Outer Banks. At the lodge, deluxe amenities like the yacht were mixed in with the rustic lifestyle of waterfowl hunting. Each member brought down a personal manservant, and in addition, the club employed local Henry Wescott as a butler. Halyburton's wife, May, retrieved daily New York Stock Exchange reports. Each of the 21 members received a key to his own bedroom on the second floor, a deed to the property, a gun locker, a liquor locker, a place to store his skiff and decoys, and use of the club's common spaces. Details about weather, numbers of kills, and species taken were entered into leather-bound game registers for 100 years. In 22 bountiful years from 1888 to 1910, a total of 72,124 ducks, geese, swan, and snipe were bagged at this one club. (Bob Furr.)

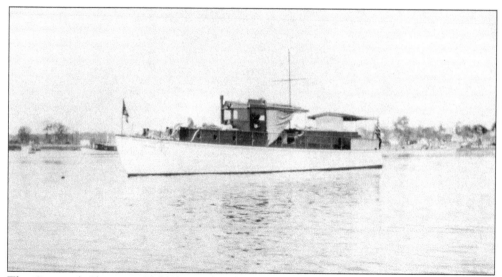

The Currituck Shooting Club's boat, the *Kermath*, carried freight from the mainland to the club's Outer Banks location. After the ocean inlets closed, Poplar Branch became the primary conduit through which people, goods, and services flowed to the remote banks. Although the Northerners were amiable and generous to locals, they did not allow any Southerners into their club until 1960. (Bob Furr.)

The grandson of Pine Island's Carl P. White, Carl Ross (left, rubbing his hands together) was the sixth and last superintendent of the Currituck Shooting Club. North Carolina federal judge W. Earl Britt (right) looked pleased with his take in 1980. A tragic loss for waterfowl heritage occurred when the club and all its decoys, documents, and other artifacts burned to the ground in 2003. (Carl Ross.)

There were four different clubs with the name Lighthouse, and they all fell in the figurative shadow of the Currituck Beach Lighthouse. Cleveland Lewark of Corolla had the third lodge named Lighthouse from 1940 to 1945. His typed postcard let potential clients know they would have electricity produced by a generator in an area that had no public utilities. (OBCWE, Steven Meade Collection.)

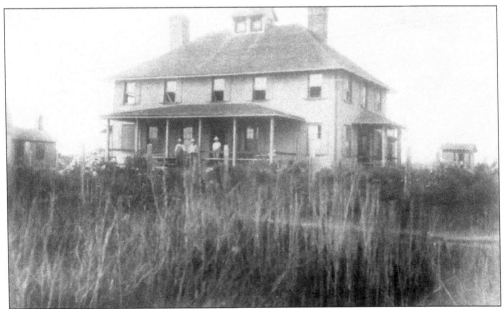

New York sportsmen founded the first Lighthouse Club in 1874. Edward C. Knight Jr., heir to his father's railroad, sugar, and publishing interests, purchased the property from a second set of owners in 1922. His vision was to build a spectacular lodge for his companion and then fiancée, Marie-Louise Josephine LeBel, who was denied entrance into the all-male membership clubs despite her love of hunting. (Carl Ross.)

With the help of a professional architect, Knight designed a house as lovely and unique as Marie-Louise Josephine LeBel Knight, his French-Canadian wife. Workers dug a six-foot-deep channel around a piece of sound shoreline to create an island. They built up the island with dredge spoil to form the construction site for the house, which is reminiscent of a castle with its own moat. (OBHC.)

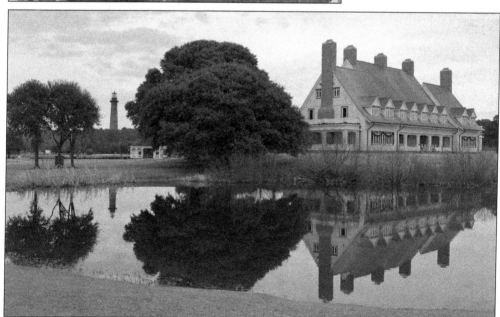

The Knights appropriately chose the name Corolla Island for their elegant home, accessed by two arched bridges. They brought the head carpenter in from Rhode Island but hired local laborers, craftsmen, and a contractor. The plans called for luxurious materials with which these workers had no previous experience. The five chimneys declared that Corolla Island would surpass all other structures in the area. (John Aylor.)

Wildfowl population numbers were decreasing at an alarming rate. Conservation societies criticized the killing of birds, like egrets and terns, just for hat feathers. They galvanized public opinion and successfully lobbied for protection of birds along the Atlantic flyway. The federal Lacey Act of 1900 prohibited the sale of game across state lines, directly targeting market hunting. (OBCWE, Steven Meade Collection.)

The United States and Great Britain (acting for Canada) entered into a treaty to establish specific hunting seasons in 1916. The Migratory Bird Treaty Act in 1918 officially made it a crime to kill or sell a migratory bird unless a permit was issued. Market gunners were out of business. Some amateur hunters, like Jim Scarborough here, kept simple clubs like the old Pell Austin home in Corolla just for friends with permits. (Karen Scarborough Whitfield.)

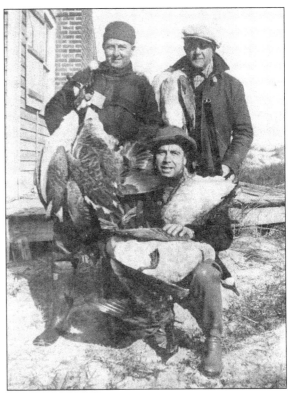

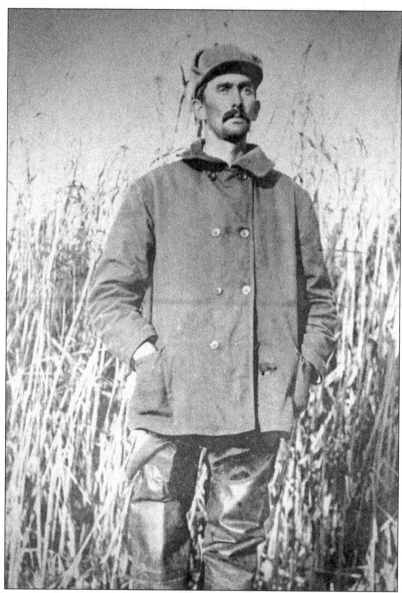

Even with new regulations, guiding and working for clubs were still sources of income for men like Ben Etheridge (shown here). A terrible tragedy that pitted local against local in 1920 illustrates how the influence of wealthy out-of-state landowners changed the dynamics of the community. St. Clair Lewark, a marsh guard for Pine Island Hunt Club, was armed with an automatic Winchester rifle provided by the club. He opened fire on a boat with two hunters because he perceived them to be trespassing. The men quickly dropped below the gunwales, but one of about 12 shots penetrated the side and entered Derwood Gallop's abdomen. Gallop and the other man in the boat, James Shannon, both identified Lewark as the shooter. Gallop died the next day. Pine Island Club owners thought a murder conviction would be bad publicity for them. Expensive lawyers were hired, and an alibi was produced. Lewark was acquitted, but his great-niece Rita Lewark Pledger recalled that he was never the same due to the guilt of the ordeal and a brutal beating received in revenge. Also scarred, of course, were the Gallops, who lost their son and were betrayed by the justice system. (Norris and Scott Austin, Archie Johnson Collection.)

Three

LOOKING SEAWARD

Pieces of shipwrecks can mysteriously appear and disappear in shifting tides. The Currituck Outer Banks lies in what writer and historian David Stick termed the "Graveyard of the Atlantic." The warm Gulf Stream meets the cooler Labrador Current, creating rough waters and underwater shoals that have sunk many a ship. Stick estimated that thousands of shipwrecks occurred off the North Carolina coast. (Lisa Griggs.)

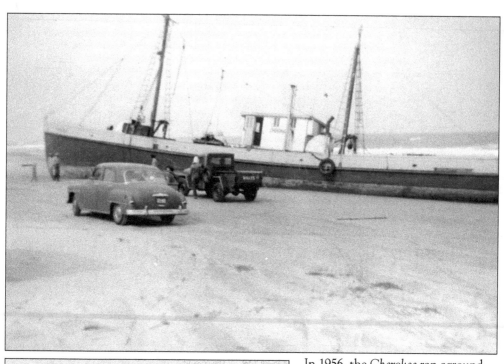

In 1956, the *Cherokee* ran aground near Corolla. A high volume of water traffic in the 1800s that cheaply and quickly moved people and goods often resulted in shipwrecks. Ships as far away as Europe and South America rode the Gulf Stream and Labrador Current to hasten their journeys. These same currents, however, took them dangerously close to North Carolina's underwater shoals. (Norris and Scott Austin.)

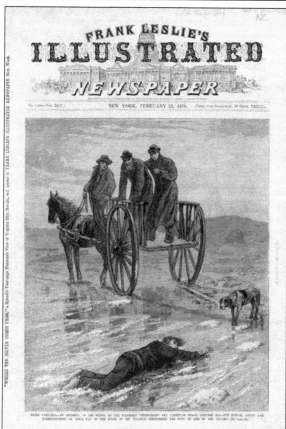

Heart-wrenching illustrations, like this sketch of surfmen collecting a drowned man in *Frank Leslie's Illustrated Newspaper*, fueled a public call for change. The federal government had begun to build lifesaving service stations to be manned by volunteers along the Atlantic coast. From 1876 to 1878, a series of devastating wrecks, two at Currituck Beach, highlighted the desperate need for better lifesaving infrastructure. (OBHC.)

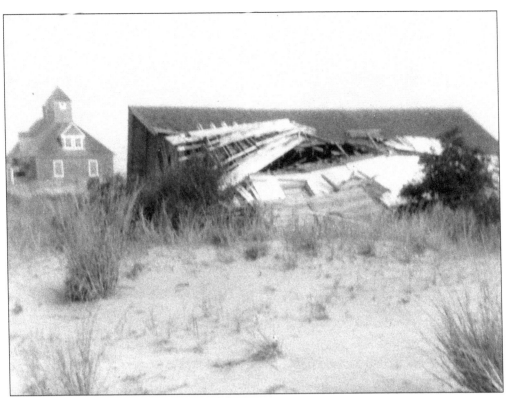

On March 1, 1876, the part-time crew of the Jones Hill Station, in ruins in the foreground of this 1960 photograph, braved cold waters to assist an Italian bark, *Nuova Ottavia*. They launched a surfboat into the breakers and arrived abreast the wreck. The frightened Italians panicked and caused the boat to capsize. Other rescue attempts failed. All of the lifesaving crew and all but four Italians drowned. (Norris and Scott Austin.)

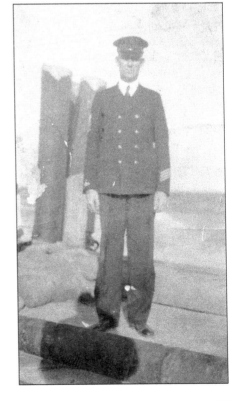

Although some derisive newspaper articles branded the surfmen as lazy, the truth was that they were part-time and hardly trained. In the early days, the positions were rewarded to cronies of politicians with no regard to skill or work ethic. Incompetent men were soon weeded out until the remaining lifesaving servicemen, like Pell Austin, were highly disciplined and deeply respected. (OBCWE, Steven Meade Collection.)

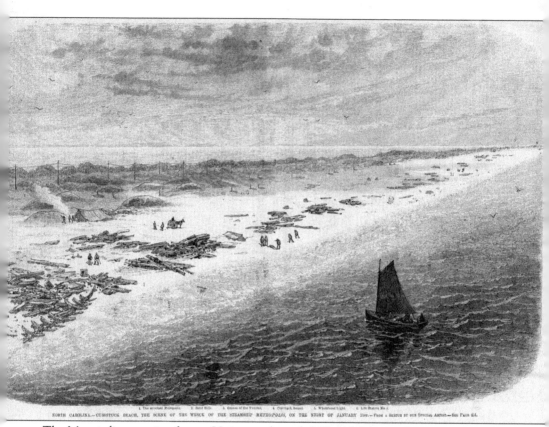

NORTH CAROLINA.—CURRITUCK BEACH, THE SCENE OF THE WRECK OF THE STEAMSHIP *METROPOLIS*, ON THE NIGHT OF JANUARY 31st.—From a Sketch by our Special Artist.—See Page 431.

The *Metropolis*, a rotting former Union gunboat, left Philadelphia with 248 people and tons of materials to construct a railroad in Brazil. Rough seas caused the improperly stored iron rails to shift and widen the seams in the hull. The ship became inundated with seawater, and by the dawn of January 31, 1878, the captain headed the *Metropolis* to Currituck Beach. Upon seeing the stranded vessel only 100 yards from the shore, citizens quickly went for help. The Jones Hill station, four and a half miles away, responded, and keeper John G. Chappell raced to the scene on horseback with his medicine chest, reviving people in the surf along the way. Leaving the station, the lifesaving crew struggled to push the cart loaded with the rescue cannon through wet sand. After the rescue cannon arrived many hours later, one out of four shots landed on the yardarm, but a wire forestay cut the line. To the horror of all, the ship broke up in the frigid pounding breakers. The lifesaving crew tried to reach the ship's passengers, who were attempting to swim or float to shore. In all, 85 people lost their lives that day. Blame landed squarely on the US Life-Saving Service. (OBHC.)

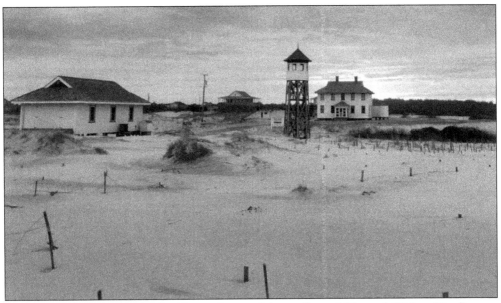

As terrible as the wrecks of the *Nuova Ottavia, Metropolis,* and *Huron* (off Nags Head) were, they brought reform to the US Life-Saving Service. Change occurred when stations were staffed with full-time crews, who drilled and practiced daily. Eventually, 29 stations were built along the North Carolina coast. They started near the Virginia border at Wash Woods (shown here) and went south. (Edward Ponton.)

Young Dan Lewark stood in front of what was likely the first Wash Woods Station. He was born at this station while his father, William Van Lewark, was keeper. The elder Lewark also served at Pennys Hill, Caffeys Inlet, and Fort Pierce, Florida. Dan Lewark's mother, Mariah Midgett Lewark of Rodanthe, accompanied her husband and cooked for the servicemen. (Rita Lewark Pledger.)

The lifesaving stations were usually spaced six to seven miles apart. Villages sprung up near stations as hired crewmen brought their families to sparsely settled areas. Homes, stores, churches, and schools improved the lot of Outer Banks children like Dan Lewark (left) and his little brother, Rondal (right). (Rita Lewark Pledger.)

The original Wash Woods Station was in the 1876-type style, and the replacement station, built in 1919 (shown here), was in the Chatham-type style. In the photograph, the net stretching from a post near the station to the foreground was being "hung"; that is sewn to a rope with buoys to prepare it for use. Lifesaving service crews supplemented their incomes by fishing with nets while on duty. (Norris and Scott Austin.)

Lifesaving service stations had large cisterns to gather rainwater from the roof for drinking. A line of telegraph, and later telephone, poles connected the stations. In 1988, the Twiddy family purchased and authentically restored the Wash Woods Station, cookhouse, boathouse, and the lookout and signal tower (shown here). They use it as a satellite real estate office today. (Karen "Spooky" Phillips.)

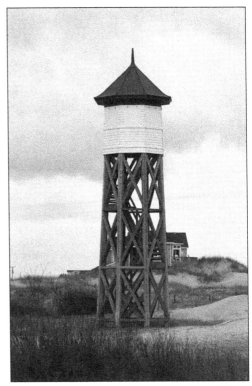

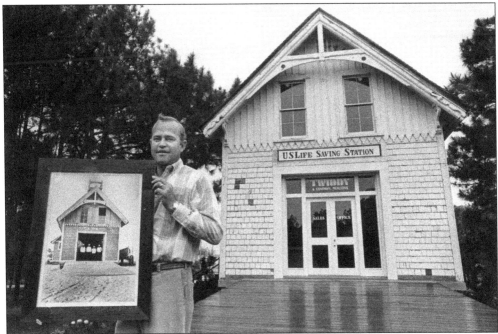

Doug (shown here) and Sharon Twiddy moved the Kill Devil Hills Lifesaving Service Station to Corolla in 1986. When the Wright brothers were conducting flying experiments, the crew of this station befriended them. This Twiddy and Company Realtors building is filled with lifesaving service artifacts and Wright memorabilia. (OBHC, Drew Wilson Collection.)

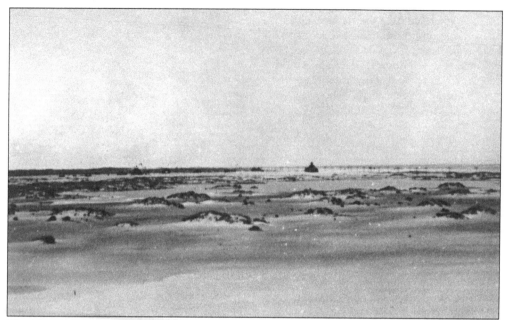

The Pennys Hill Station looks like a lonesome outpost in 1939 with the telegraph poles as the only sign of civilization. Not only did the stations house victims of shipwrecks until they were well enough to leave, but they also served as places of rest for travelers. Bankers driving their livestock to up to Virginia markets stopped overnight. Isolated crews enjoyed the company. (Barbara Haverty Pardue.)

Pennys Hill Station became even more dilapidated after the Ash Wednesday Storm of 1962. Surfmen from each station went out on foot or horse patrol looking for vessels in distress. Men of neighboring stations exchanged tokens upon meeting to prove the area had been patrolled. Sometimes, surfmen confirmed the end of the patrol by inserting a key in a watchman's clock mounted on a post. (Barbara Haverty Pardue.)

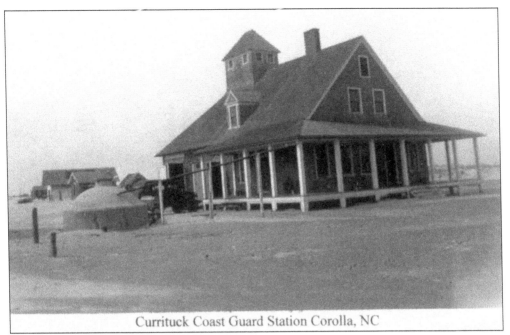
Currituck Coast Guard Station Corolla, NC

The Currituck Beach Station was built as a replacement for the Jones Hill Station. It later became a US Coast Guard station. Many stations had a series of different structures of various architectural styles over the course of their histories. Adding to the complexity, unused buildings were treated as government surplus and often sold to citizens or moved to another federal site. (Norris and Scott Austin.)

The Poyners Hill Station, 5.5 miles south of the Currituck Beach Station, was built in response to the *Metropolis* tragedy. This cedar-shingled Chicamacomico-type style building was pictured here in 1955. The sparse population on this section of the beach made it a safe spot for migrating birds. During World War II, the station was reactivated as a Navy radio post. (NPS, CHNS.)

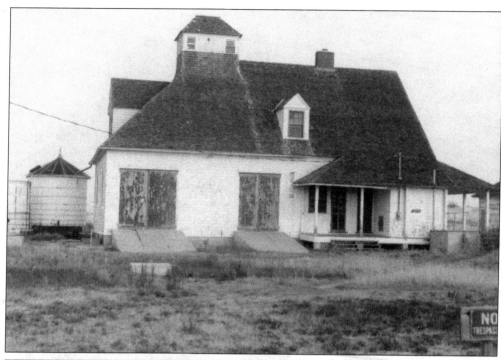

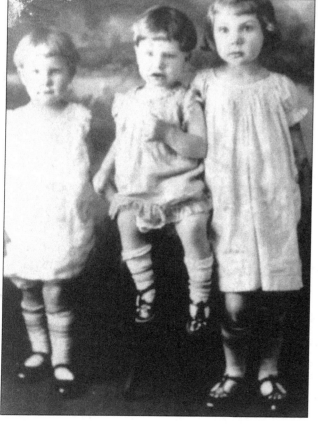

Caffeys Inlet Station, north of Duck, was once in a state of disrepair. Caffeys Inlet surfman Malachi Corbell was awarded a silver Congressional Lifesaving Medal for his 1875 rescue of two African American fishermen whose boat overturned offshore. Sadly, two of his lifesaving service crew perished. Today, the Caffeys Inlet Station is refurbished and is being used as a restaurant in the Sanderling Resort. (Carl Ross.)

From left to right, sisters Ann, Mabel, and Myrtle Beasley grew up in the tight-knit village of Wash Woods. In the event of a wreck, the compassionate villagers assisted the lifesaving service by administering aid, lighting driftwood fires to warm survivors, and cooking food for them. The villagers even pulled bodies out of the surf. Shipwreck victims were usually buried in the dunes. (Barbara Haverty Pardue.)

Usef Beasley served at Wash Woods, and his wife, Lucy White Beasley, grew up in the vicinity at her family's hunting lodge. Station records reveal that, in addition to the local families, employees of the many hunting clubs fearlessly aided the lifesaving service surfmen. In an area with little medical care, villagers looked to the stations as places of aid, and keepers took on early paramedic roles. (Barbara Haverty Pardue.)

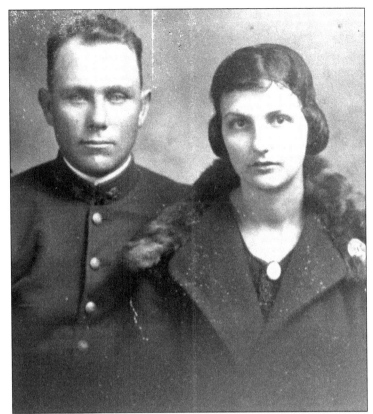

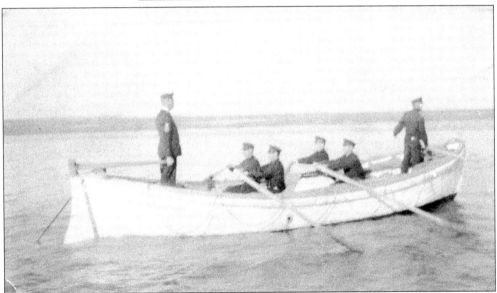

Pell Austin (left) of Corolla led his Sullivan's Island, South Carolina, crew in a surfboat drill. The importance of having proper policies and procedures for the lifesaving service was driven home after the wreck of the *Nuova Ottavia*. Cork life belts issued by the lifesaving service were left hanging on their hooks in the boathouse while rescuers and passengers drowned. (Norris and Scott Austin.)

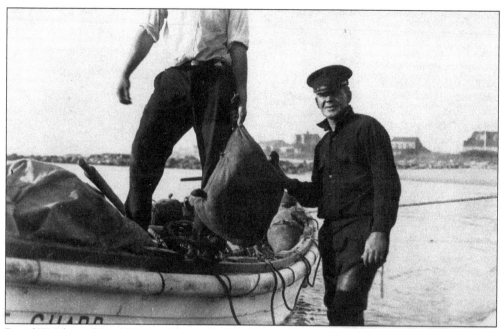

David Wright and David Zoby in *Fire on the Beach* wrote that surfmen, like the ones pictured here, performed good deeds, such as "cornering thieves; capturing two runaway boys; apprehending 'lunatics' who had escaped from an asylum; as well as assisting other branches of the federal government, from the Corps of Engineers and the navy, to the Immigration and Public Health Services and the Post Office." (Bobby Meade.)

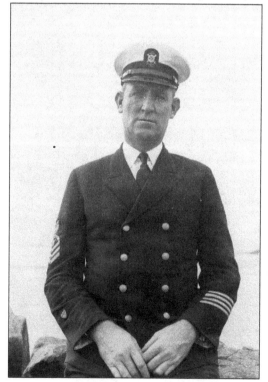

Pell Austin proudly wears his lifesaving service uniform. When the lifesaving service merged with the Revenue Cutter Service in 1915 to become the US Coast Guard, Austin made the transition. Although the early history of the lifesaving service was full of deadly errors, no one can doubt the bravery of the Outer Bankers who laid down their lives for people who were total strangers. (OBCWE, Steven Meade Collection.)

Four

SETTLEMENT ON THE OUTER FRINGES

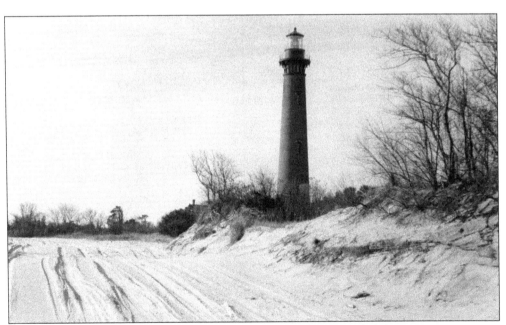

In 1852, the US Congress created the Lighthouse Board to erect lighthouses in response to shipwrecks along the East Coast. The Civil War stalled an ambitious plan for constructing additional lighthouses. In 1873, Congress allocated $50,000 to "illuminate the dark space" of the Currituck Outer Banks between the lighthouse towers at Cape Henry, Virginia, and Bodie Island, North Carolina. (Norris and Scott Austin.)

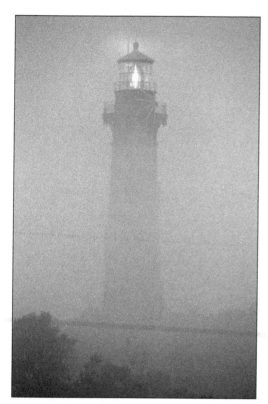

The 66 land miles between lighthouses at Cape Henry, Virginia, and Bodie Island, North Carolina, translated into 40 sea miles of "dark space," where the lights did not reach. Ideally, a captain should be able to see the next light off his bow just as the last light disappears off his stern. It is no surprise that due to this void, 56 vessels had gone ashore on Currituck Beach from 1852 to 1874. (John Aylor.)

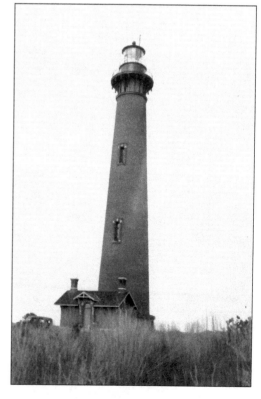

Well over a million red bricks were need to build the 162-foot conical lighthouse. For easy daytime identification, the Lighthouse Board decided Currituck Beach Lighthouse would remain unpainted. Other similar towers were distinctively painted black and white: Bodie Island with horizontal bands, Cape Hatteras with spiral stripes, and Cape Lookout with a diamond-shaped pattern. (NPS, CHNS.)

A riverboat from Norfolk delivered brick to the sound-side wharf and railway tram, which was erected specifically to roll heavy materials to the building site. The immense project fell under the supervision of Dexter Stetson, who had overseen the building of the Bodie Island and Cape Hatteras towers. A firm foundation was made with pilings, a grid of 12-by-12-inch timbers, and a wide octagonal stone base. (NPS, CHNS.)

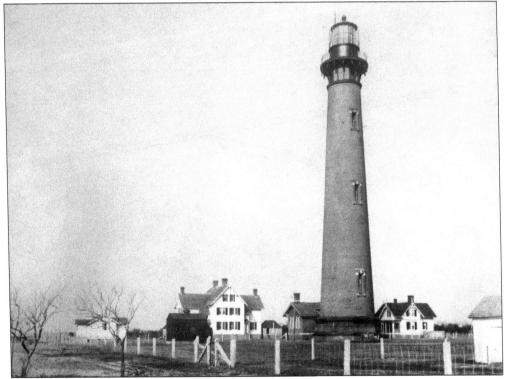

To enter the lighthouse tower, keepers walked through the oil house, where an office and workshop were located as well as fuel for the light. Interior walls were five feet, eight inches thick at the base and three feet thick at the top, creating the tapered shape. A spiral wrought iron staircase with nine landings led to the top. Windows alternating on each side provided natural light and incredible views. (Norris and Scott Austin.)

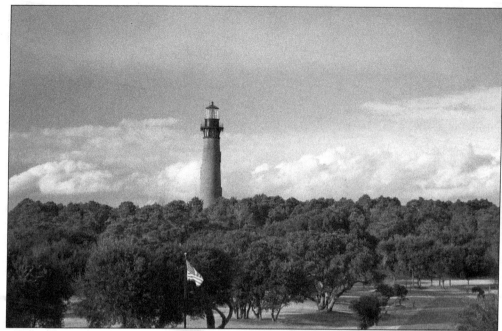

The crowning glory of the Currituck Beach Lighthouse is the large, first-order Fresnel lens, called the invention that saved a million ships. The light source, once a circle of oil wicks, now an LED array, is surrounded by slices of glass lenses that are prisms to reflect and refract the light. This compact system enables the Currituck beam to be seen for 18 nautical miles. (John Aylor.)

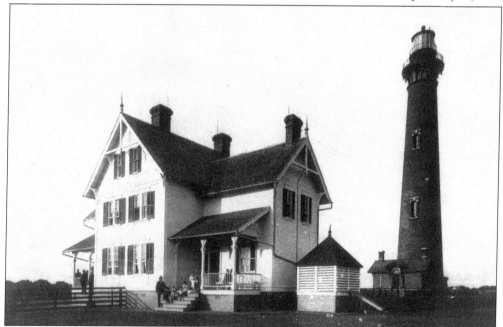

Henry Bamber, an engineer for the US Lighthouse Service, captured this iconic shot of the Currituck Beach Light Station in 1893, not too long after it was completed in 1875. The house was outfitted with lightning rods since the area has always experienced a high number of strikes. An elaborate gutter system funneled water into two louvered cisterns. (Outer Banks Conservationists.)

The beautiful symmetry of the keepers' house can be seen from the gallery decks of the lighthouse. The Victorian-style duplex was prefabricated using standard housing plans for a first-order lighthouse station. The unassembled house was shipped by barge and completed as a home for the keeper, two assistant keepers, and their families. The two sides were mirror images, down to walkways to the lighthouse. (John Aylor.)

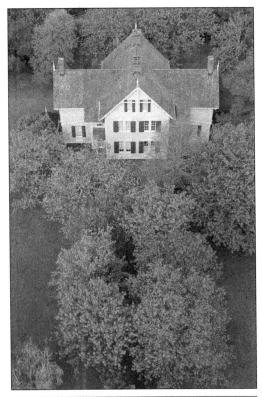

With three positions for keepers, two families had to share a duplex side until 1920, when this residence was moved to the lighthouse station site by barge from Long Point Beacon Light on mainland Coinjock. Close proximity had led to some quarreling. A letter to the keepers from the superintendent of lights instructed the following: "Give no cause for offense and endeavor to get along quietly with all." (NPS, CHNS.)

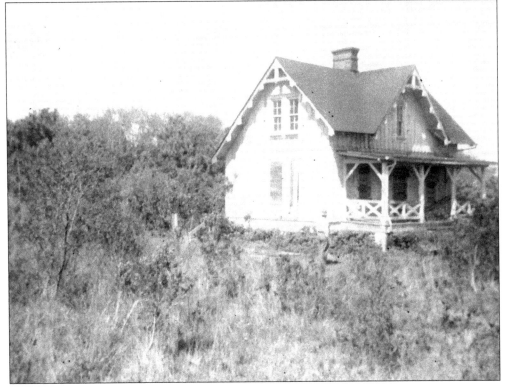

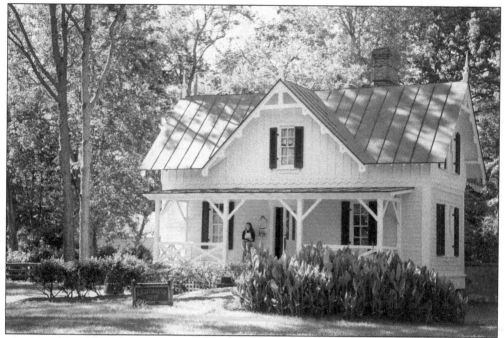

The Little Keepers' House has been meticulously revived. Decorative elements like both vertical and horizontal siding, wooden finials on the roof, and crossbars and king posts on the gabled ends blend motifs that some call Carpenter Gothic and others call Victorian Stick style. When restoration of the light station began, volunteers discovered this house in overgrown woods. (Francesca Beatrice Marie.)

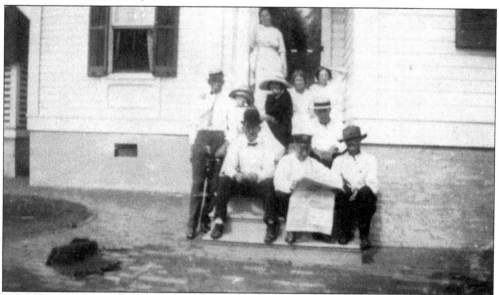

This photograph was taken during George Johnson's era. In 1912, second assistant Johnson requested a lateral transfer from Cape Henry, Virginia, to Currituck Beach. He had three young children, and the school in Virginia was six miles away. He wanted to move to Currituck Beach, where there was a nearby school. He stayed 17 years after receiving permission to move. (Outer Banks Conservationists.)

A mid–20th century photograph shows the keepers' quarters in sad repair. Keepers were to operate the light, clean and paint the station and houses, care for the grounds and outbuildings, maintain machinery, keep records and write reports, go for mail and provisions, observe weather, prepare meals, and even report on flight patterns of waterfowl. (Barbara Haverty Pardue.)

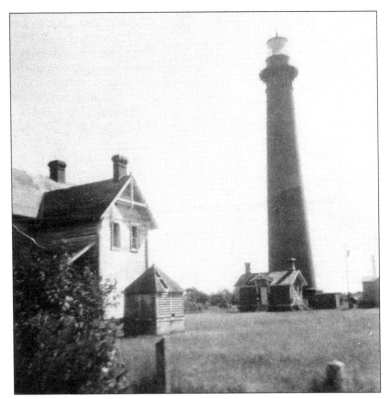

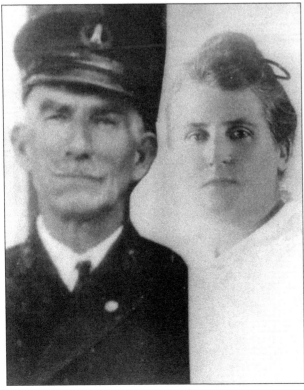

Wesley Austin and his wife, Belle Barnett Austin, were natives of Hatteras Island who moved to Currituck Beach for the first assistant keeper job. Records show that he earned $500 a year in 1903 and $1,440 a year when he retired in 1929. He worked with his brother William Riley Austin, who was hired as second assistant keeper. (Outer Banks Conservationists.)

When William Riley Austin made keeper in 1921, his wife, Lovie (left), and children, John and Jenny, must have been proud. Austin served 40 continuous years in the lighthouse service despite his limited education. As part of the job, keepers and assistants swore an oath of office to support and defend the Constitution against all enemies, foreign and domestic. (Norris and Scott Austin.)

In 1937, William Riley Austin (below, right) was still as sturdy as the beacon he was charged to keep. According to the 1914 light station journal, "The first assistant (Austin) awhile hoisting the lantern curtains preparatory to light stepped backwards and fell down the stairs way which rendered him unconscience [sic] for a while and inflicted external injuries. He was confined to his bed three days." (Outer Banks Conservationists.)

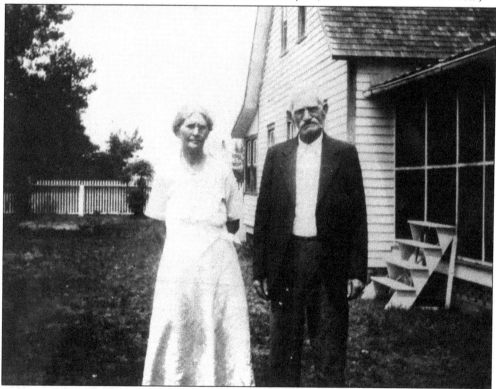

The Austins remained in Corolla even when the population dwindled down to less than 20 in the 1970s. John Austin (shown here), son of William Riley and Lovie, served as postmaster as did his son Norris. John had a second son, O.W., whose children and grandchildren are the fourth and fifth generations to sleep under the steady beam of the Currituck Beach Lighthouse. (Norris and Scott Austin.)

Charlie Pugh posed in the military-style uniform of a keeper. In addition to providing navigational aid, the lighthouse towers along the ocean and the screw-pile lighthouses in the Albemarle and Pamlico Sounds created a strong federal presence in a remote area. Government salaries, pensions, housing, weather data, and means of communications all enhanced the quality of life in eastern North Carolina. (RWG.)

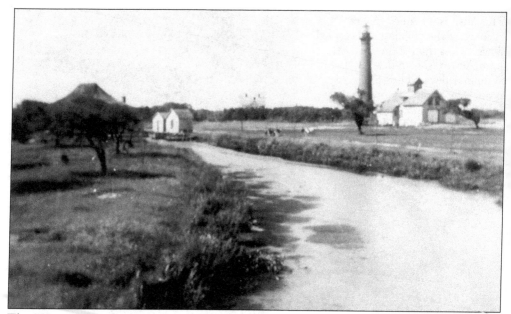

The US government also influenced architecture by employing professional engineers and architects who had studied abroad. These days, their design ideas can still be seen in everything from surf shops to bathhouses. The Currituck Beach Lifesaving Service Station with wide doors for surfboat bays and a square watchtower is pictured south of the Currituck Beach Lighthouse in 1955. (NPS, CHNS.)

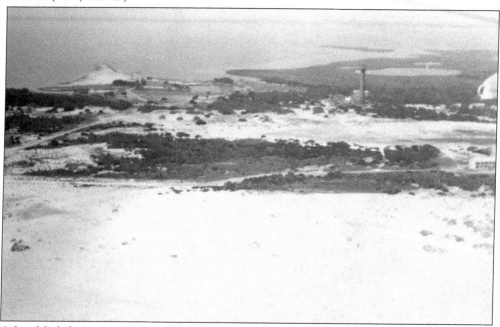

A local lighthouse serviceman often took an out-of-state lighthouse assignment. The move allowed him to return to his beloved Outer Banks at a later time with a higher rank and improved position in the service. Physically demanding lighthouse jobs also carried terrific responsibility. If the light went out, even for a short time, a full report had to be made of the circumstances that caused those dreadful dark moments. (NPS, CHNS.)

Lighthouse families kept livestock and tended gardens. Often, a devoted dog followed the keeper on daily trips up and down the stairway. Keepers had many duties. They took lard oil, and later mineral oil, to the top in large buckets or cans to fill the fuel repository. They trimmed wicks and cleared fuel lines. They polished lenses and wound the clockwork that kept the light revolving. (Francesca Beatrice Marie.)

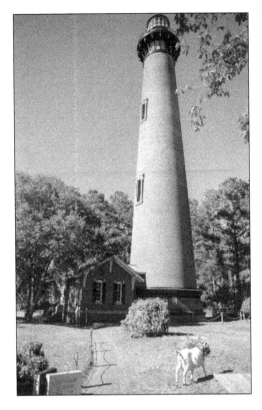

Homer T. Austin, the last keeper before the Currituck Beach Lighthouse was automated in 1937, held his baby grandson, none other than coauthor R. Wayne Gray, in 1944. Since there was no electricity on the Currituck Outer Banks until 1955, batteries were installed to keep the light beaming. And since the station was vacant, a keeper from the Coinjock Depot came over weekly to charge the batteries. (RWG.)

In 1939, the US Coast Guard assumed the responsibilities of the Bureau of Lighthouses. In 1940, a Coast Guard crew tended to the Currituck Beach Lighthouse. They charged the batteries, maintained the Fresnel lens, painted the tower interior, and cut the grass. In 1944, these coasties posed in front of the Currituck Beach Lifesaving Service Station, where they were housed. (Norris and Scott Austin.)

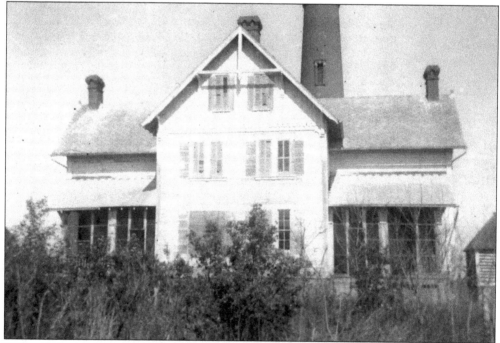

When electricity came to Corolla in 1955, there was no longer a need to charge batteries, but a generator was on site in case of power failure. In 1963, the US Coast Guard hired civilian personnel, called "lamplighters," to keep up the Currituck Beach Lighthouse. Quarters and outbuildings started to deteriorate, and descendants of wreckers helped themselves to wainscoting and mahogany balustrades. (NPS, CHNS.)

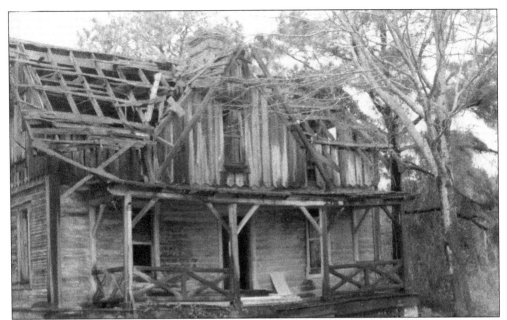

John Wilson, an architect from Manteo and the great-grandson of keeper Homer T. Austin, took an interest in the neglected Currituck Beach Lighthouse Station. He and a small band of friends formed Outer Banks Conservationists in 1980. The group signed a lease with the state and began a well-researched restoration of the main house. They also restored the Little Keepers' House, pictured here in a pitiful state. (RWG.)

In the early 1980s, Manteo Elementary School students ate their lunches on the grounds of the Currituck Beach Lighthouse during a field trip to Corolla to see a beached whale. The right side of the picture shows new siding on the main keepers' house. The nonprofit Outer Banks Conservationists raised money by donations and state and federal grants. After 1990, citizens could climb the lighthouse. (RWG.)

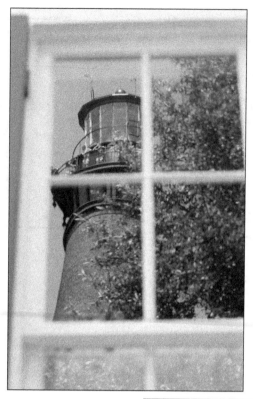

The National Historic Lighthouse Preservation Act in 2000 made the Currituck Beach Lighthouse available to certain entities. Both Outer Banks Conservationists and Currituck County applied for ownership, scaling up a dispute that US congressman Walter Jones called the "fight for the light." In the end, Outer Banks Conservationists was awarded the deed to the lighthouse tower for its years of work. (John Aylor.)

The Currituck Beach Lighthouse was as familiar as the moon and the stars to, from left to right, Norris Austin, Jewel Scarborough, Nellie Myrtle Pridgen, and Steven Meade. Advertisers have used photographs of wild horses and open beaches to draw tourists to the Currituck Outer Banks, but the image of the lighthouse represents stability, safety, and home to the local people. (Karen Scarborough Whitfield.)

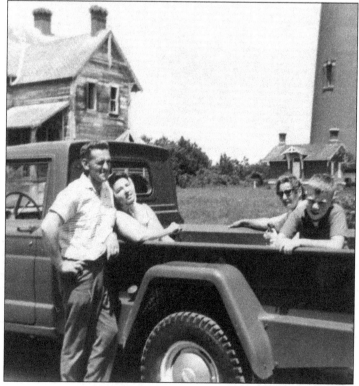

Five

ISOLATED VILLAGES

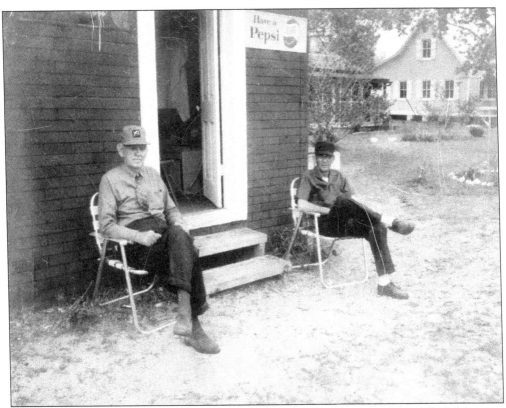

Corolla's fifth postmaster John Austin (left) shared small talk with Griggs O'Neal (right) during a slower-paced time. Austin built this store so he could sell homemade ice cream to the construction workers of the Corolla Island mansion. When he got the postal contract, he moved this building closer to his house and operated the Corolla Post Office out of the store from 1935 to 1959. (Norris and Scott Austin.)

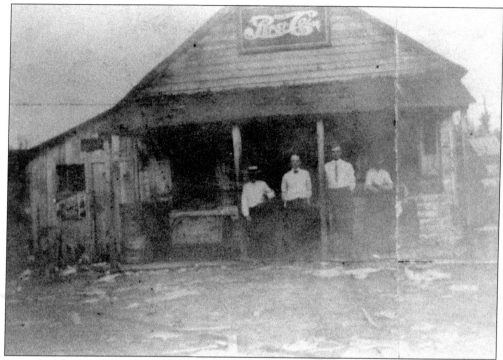

Men also liked to gather at Callie Parker's store, shown here about 1931, to pass the time and tell tales, or "yarns" in the local vernacular. The audience delighted in the particulars, and the storytellers would not disappoint, recalling every detail down to which direction the wind was blowing that day. When radio came along, they would gather in stores to listen to the *Grand Ole Opry*. (Norris and Scott Austin.)

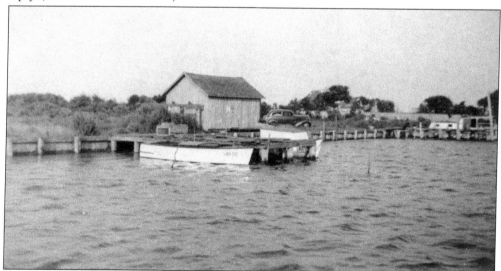

To establish postal service for a community, a prominent citizen, usually a merchant, made an official request that included an estimation of the number of people who would be served and the name of the nearest post office from which mail could be delivered. In 1885, a mail boat from mainland Waterlily delivered mail to Corolla's landing for handling by the first postmaster, Emma Parker. (OBCWE, Steven Meade Collection.)

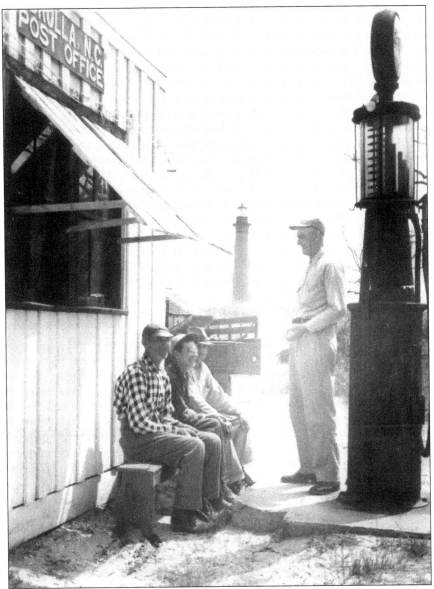

A captive and rapt audience was ready to hear new gossip or an old yarn from a raconteur in the 1950s. Before being named Corolla in 1895, the village was known as Whales Head for more than 100 years. There are two possible origins of that name. An intriguing, age-old story tells of a resident who drove his horse-drawn wagon through the open jaws into the head of a large beached whale. Another less riveting explanation is that the area's crescent shaped dunes looked like the heads of whales. The village was also known as Jones Hill for the towering sand dune of the same name and as Currituck Beach for the lifesaving station and lighthouse that were located there. The US Post Office Department chose another submission, Corolla. Lewis Simons, a schoolteacher, suggested the name because it denotes the inner circle of petals of a flower, and Corolla was a beautiful center to the surrounding area. Using the soft-vowel sounds of a North Carolina speaker, it is pronounced, "kuh-RAH-Luh." When visitors pronounce it, "kuh-ROE-Luh," like the Toyota vehicle, it is a sure sign that they are new to the area and have not yet been corrected by a local. (Norris and Scott Austin.)

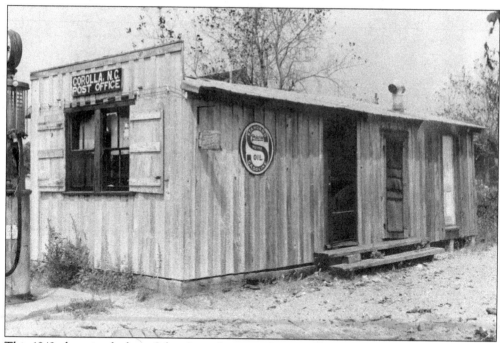

This 1942 photograph shows John Austin's store, where Esso/Standard Oil gasoline was sold. It was brought over by boat in 55-gallon drums from Poplar Branch and rolled into a sound-side warehouse. When needed, the drums were rolled up boards into a truck and brought over to the store, where the gasoline was transferred to an underground tank. Customers bought five gallons at a time for vehicles or generators. (OBHC.)

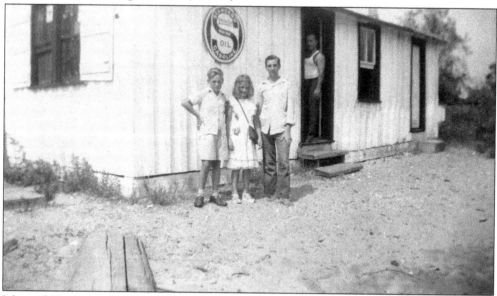

John and Virginia Austin's sons, Norris (left) and O.W. (right), pose with their friend Judy Hampton in 1949. The store was stocked with canned and dry goods, bottled soft drinks, crackers, and candy. During World War II, extra military servicemen were stationed in Corolla, and there was a surge in store traffic and post office volume. John Austin's store served as a post exchange for the US Coast Guard. (Norris and Scott Austin.)

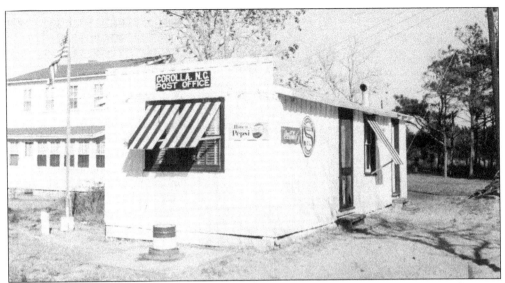

Outer Banks postmasters took on the functions of today's chamber of commerce. People wrote to inquire about goods they wanted to buy, vacation accommodations, or how best to get to their destination. The most famous example occurred when postmaster Will Tate corresponded with the Wright brothers about the favorable conditions in Kitty Hawk for their flying experiments. (OBHC.)

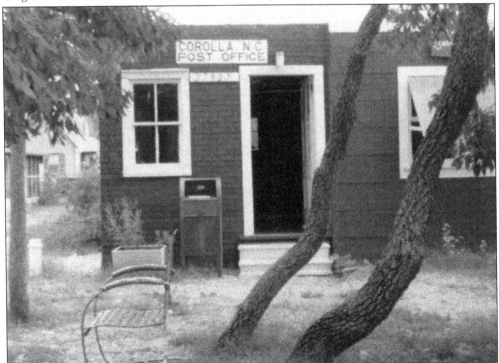

A new zip code and prefab concrete steps date this photograph to the 1960s. Residents recalled that Marie-Louise Knight, the lady of the grand Corolla Island home, purchased a great many stamps from the Corolla Post Office to ensure that it stayed in business. With her impeccable taste in decor, it is a good thing that she did not see this modern layer of fake brick asphalt siding. (Joe Simons.)

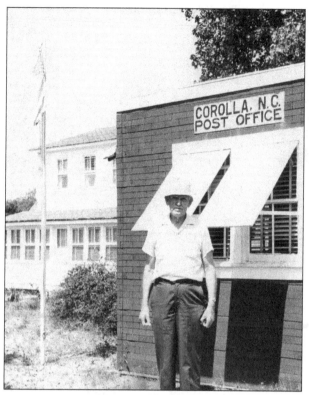

Before electricity came to Corolla, a bank of batteries charged by a gasoline generator ran the lights in the post office. The lights started dimming in the evening at seven o'clock, and they were out by nine o'clock when John Austin closed down the store. A woodstove provided heat. According to Austin's own standards, he was slightly underdressed here. Austin usually wore a collared shirt and tie. (Norris and Scott Austin.)

Norris Austin lived his entire life in Corolla except for a few years after high school. He took on the role of postmaster and shopkeeper in 1959 when his father retired. There was no early retirement for Virginia Austin, who first worked as assistant to her husband, John, and then to her son Norris. (Norris and Scott Austin.)

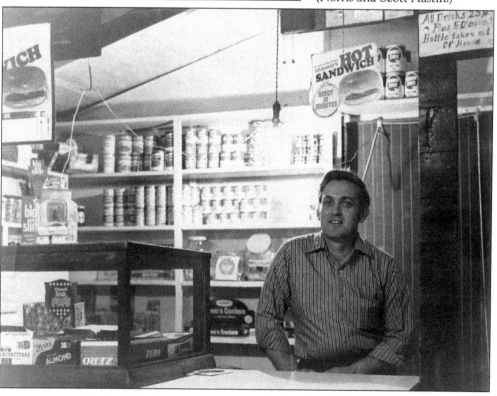

The old post office closed in 1981. Norris Austin (left) constructed a commercial building on the main highway with space for a modern post office, several retail units, and an apartment for himself. He retired in 1992. His longtime friend, author Suzanne Tate (right), recorded his remembrances of Corolla in a short book, *Whalehead, Tales of Corolla, N.C.*, in 1987. (OBHC.)

Norris Austin (right) took a smoking break and laughed with Griggs O'Neal (left). Austin became an unofficial ambassador for the village, which grew exponentially during his lifetime. His 33 years as postmaster gave him opportunities to welcome tourists and new residents. How fortunate for lovers of history that he shared his stories and knowledge before passing away in 2017. (Norris and Scott Austin.)

Two carpenters, Sol Sanderlin and Val Twiford, built a one-room chapel in 1885 with a capacity of 100 in a village of about 200. The year 1885 was the same in which the post office was established and 10 years after the lighthouse was built. It was intended to be interdenominational church, but someone went to the mainland and registered it as the Whales Head Baptist Church. (Bobby Meade.)

Circuit-riding clergymen arrived by boat and came at intervals as members of the Baptist Conference. Sunday school was still held every week. Congregants waited for the preacher to come to be baptized or married. Going to services was the social and spiritual highlight of the week for members of the community, such as the Austin family pictured here. (Norris and Scott Austin.)

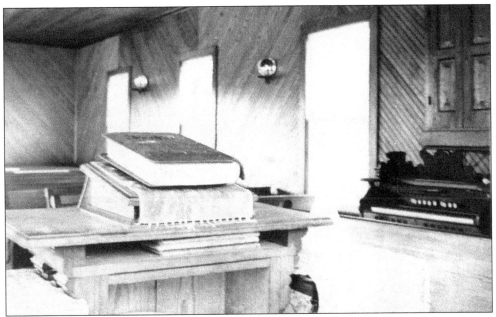

When the church was certified as Baptist, a split occurred, and the Methodists left to form a church at Seagull, near Pennys Hill. No doubt the federal salaries earned by the men in the lighthouse and lifesaving services helped the congregation afford the detailed woodwork, pump organ, and furniture. Mirrored candle sconces illuminated the sanctuary. The Bible took center place in the pulpit. (OBHC.)

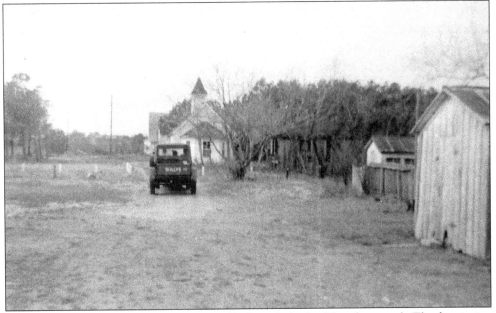

"Business area of Corolla in 50s" is the comic blurb on the back of this photograph. The description is not a stretch since the school, church, store, and post office were all located along the same unpaved lane. This Willys Jeep approached the church from the rear. Whales Head Church was part of the Baptist denomination from 1885 to 1938. After that time, the church was simply known as Corolla Chapel. (Norris and Scott Austin.)

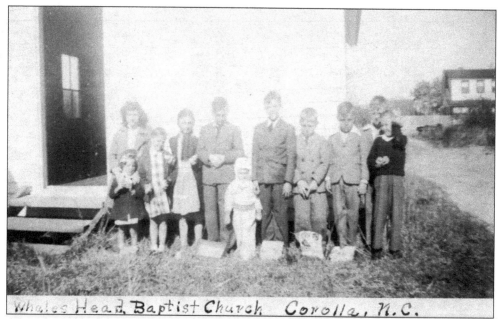

Whales Head Baptist Church Corolla, N.C.

After the lighthouse was electrified, lifesaving stations were decommissioned, and hunting opportunities declined, many local people moved to the Tidewater Region of Virginia for jobs with steady paychecks. These boys in suits and ties and little hands clutching colored eggs are clues that this picture was taken on a sunny Easter Sunday. (Norris and Scott Austin.)

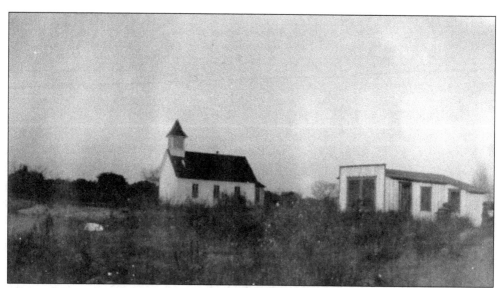

The small core of Corolla Chapel members did the best they could by hosting occasional visiting preachers. Attendance was robust during World War II when US Coast Guard families attended both Catholic and Protestant services at the chapel. By 1962, however, the chapel was listed as an abandoned property and was going to be sold at a county tax sale. John Austin protested and purchased the deed. (Norris and Scott Austin.)

Marie Sanderlin in heels and pearls seemed wishful for Sunday services in 1960. In 1983, two divinity students, Jim Bender from Pennsylvania and Rich Borg from Texas, spent summer weeks ministering at the chapel. John Austin paid for electric lighting, a new roof, and fresh paint. Bender and Borg responded to a community growing in year-round residents and repeat vacationers. (Norris and Scott Austin.)

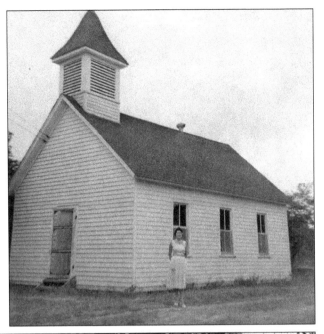

In 1987, Rev. John Strauss and his wife, Ruth, answered the call to conduct services year-round at Corolla. He was shocked to see weeds growing through the floorboards. The lack of heat kept his sermons short in the winter. The Austin family made a gift of the structure with the stipulation that it would be an interdenominational Christian church. Norris gave the building one last check. (Norris and Scott Austin.)

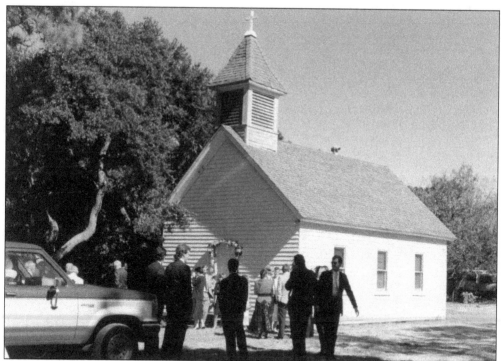

The Corolla Chapel was picture perfect on Fran and Bernie Mancuso's wedding day in 1990. Around 50 permanent residents come to services at the chapel in the off-season, and attendance swells to 300 during warmer months. One innovative ministry came in 2015 when church members provided bicycles to international students. Over 250 bicycles provide transportation for the seasonal workers. (Fran Mancuso.)

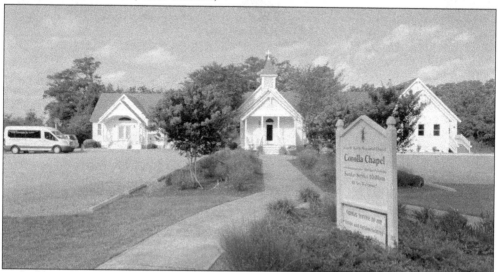

Members of Corolla Chapel's congregation have mindfully preserved their heritage, engaged in current ministries, and planned for a promising future. To make their dreams a reality, they moved the original chapel across the street in 2002 and incorporated it into the design of a larger structure in a cruciform shape. In November 2020, the members celebrated the dedication of a new fellowship hall and kitchen. (Corolla Chapel.)

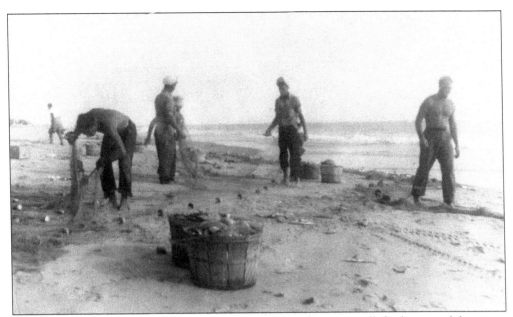

Government jobs dried up and wildfowl decreased, but there was still the bounty of the ocean to be harvested. Commercial fishing is a skill that has to be handed down from one generation to the next. Woodson Midgett (third from left) and his brother Jethro Midgett Jr. (right) had a wealth of knowledge in that respect. (Jeffrey G. Midgett.)

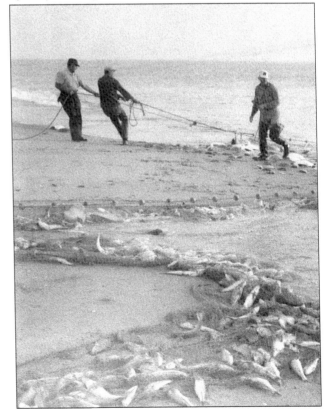

Brick Brickle and his crew pulled a beach seine net out of the ocean in the 1950s. No one in Corolla ever went hungry. Although villagers did not have much, they did share what they had with neighbors. Outer Bankers, a bit removed from the outside world, did not feel the full weight of the Depression since they were already living with scarce means. (OBHC.)

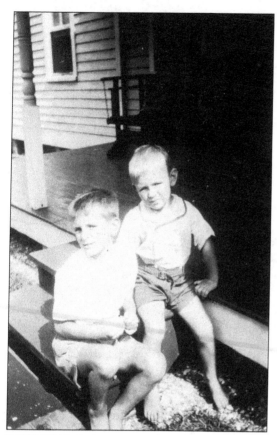

Brothers Ottley "O.W." Austin (left) and Norris (right) were explorers and scroungers like their ancestors. Children in the early 1900s scoured the sand hills looking for bones and teeth from cattle and other animals. L.R. White of Pennys Hill bought them from the children and sold them in Norfolk to button manufacturers. (Norris and Scott Austin.)

This proud group bagged a boar in 1958. Roaming domesticated pigs wisely hid in the marsh and woods at roundup time, becoming feral and sometimes aggressive. Norris Austin (second from right) built large box traps and caught enough stock to start raising piglets. Austin boasted his pen was the most expensive in the world since it was made with mahogany boards washed up on the beach. (Norris and Scott Austin.)

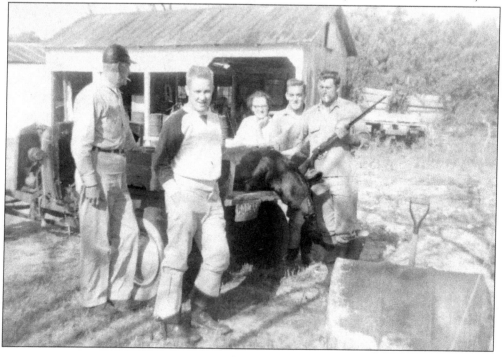

Ernie Bowden (left), tan and sinewy, sat with his friend Jethro Midgett Jr. (right) in 1940. Bowden fished, wrangled cattle, and covered every square foot of the Currituck Outer Banks. With the authority of over 90 years of experience, a still sharp Bowden declares that horses have not continuously roamed Currituck Beach since the days of the explorers. Today's wild herds are relatively new. He turned loose some stock himself. (Jeffrey G. Midgett.)

Several Currituck Beach natives have stated that horses kept by the lifesaving service crewmen were set free when the stations were decommissioned in the 1930s. In addition, locals remember that many domesticated horses escaped their enclosures during the Ash Wednesday Storm of 1962. The flooding was so severe that horses swam right over their fences. Like the hogs, they became feral and good at avoiding roundup. (Karen "Spooky" Phillips.)

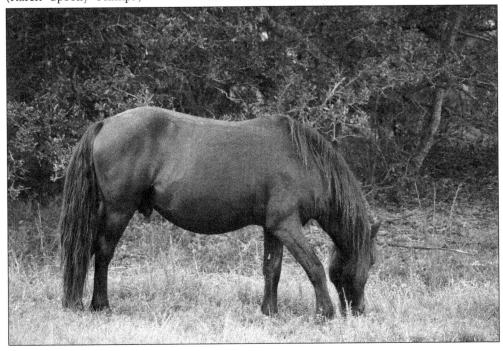

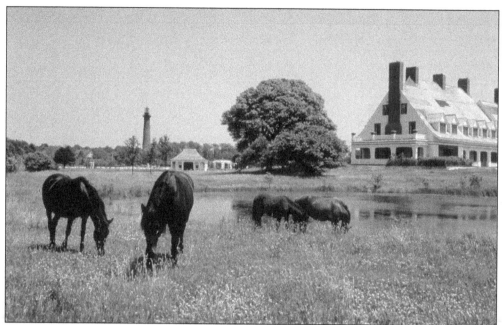

Bowden said that beach inhabitants in his father and grandfather's time knew each horse by name and to whom it belonged. Local Scott Austin explains that leaving a horse, a valuable asset, to roam unclaimed in that era would be as unthinkable as leaving a brand new truck with a free title and a key in the ignition untouched on the beach in today's era. (The Whalehead Club.)

The sparse human population in the 1960s and 1970s allowed horses to quickly multiply. Vegetation also grew rapidly, affording protection and shelter. Horses were seen to be a nuisance of little practical value. As tourism took off, savvy entrepreneurs outfitted open-air vehicles with rows of seats to take paying clientele to see wild horses safari style. Four-wheel-drive vehicles prowled a Carova neighborhood in 2020. (Karen "Spooky" Phillips.)

Six

A PRISTINE PIECE
OF BEACH

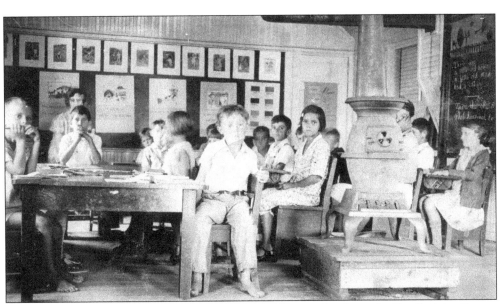

The girls were well shod, but the boys preferred to go barefoot on this day at the Corolla Schoolhouse. Older children were given the job of lighting a fire in the potbellied stove early enough to warm up the classroom. The school was well equipped with sturdy tables, chairs, and desks. The ample blackboard space and printed posters were simple but adequate. (OBCWE, Steven Meade Collection.)

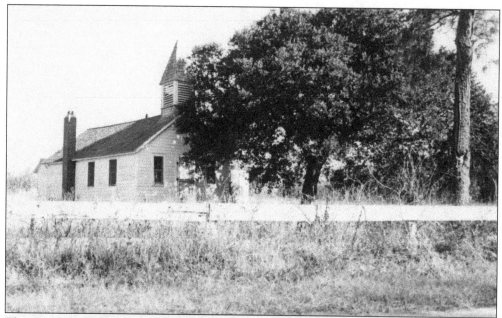

There is no recorded date of when the public schoolhouse was built, but families recall that their ancestors attended class there as early as 1896. Once again, Sol Sanderlin and Val Twiford, the two carpenters who built the chapel, were tapped to provide an essential structure for the community. Before 1896, parents organized private schools and furnished room, board, and a salary for the teachers. (OBHC.)

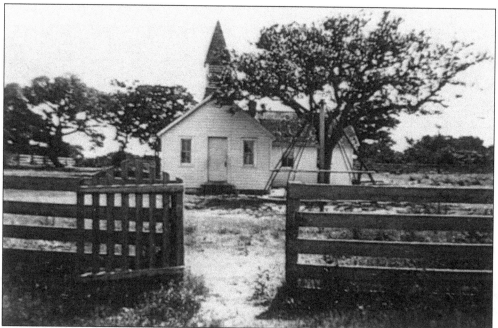

In 1905, the Currituck County School System provided a teacher, schoolbooks, and standardized grading practices for the Corolla Schoolhouse. A perpendicular ell for a lunchroom and more classroom space was added to the south (right) of the original structure. Oak trees and a fence have always been part of the outdoor grounds. (Bobby Meade.)

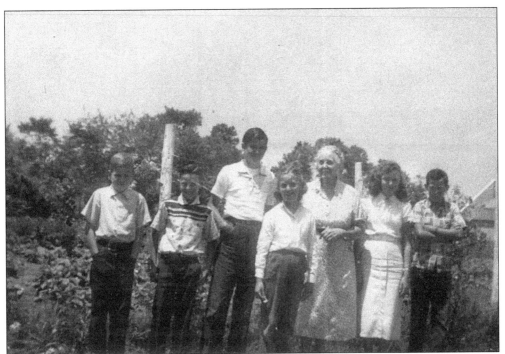

In this 1956 photograph, the entire student body posed with their favorite teacher. From left to right are Joe Ray Simons Jr., Cecil Midgett, Ray Midgett, Meta Eippert, teacher Grace Lewark, Louise Bowden, and Earl Simons. Joe graduated with honors from Old Dominion, and Earl graduated from West Point. Joe joked, "Pretty good for brothers who started in a two-room schoolhouse." (Joe Simons.)

Every school needs a school bus, and Corolla was no different. To head north to Wash Woods, the driver traveled over a ramp to reach the beach. The "wash," the hard-packed sand near the breakers, could be as smooth as a racetrack or as a dangerous as a minefield when the stumps were exposed. To head south, the driver would follow the "pole road." (Norris and Scott Austin.)

The pole road was established as an access road to maintain the telegraph utility poles that connected the lifesaving stations. It was a reliable but bumpy way to travel. A driver could use the beach wash as a roadway as far south as Poyners Hill. Father south than Poyners Hill, however, only the pole road was used since patches of loose gravel on the beach acted like quicksand and could sink a vehicle. (Carl Ross.)

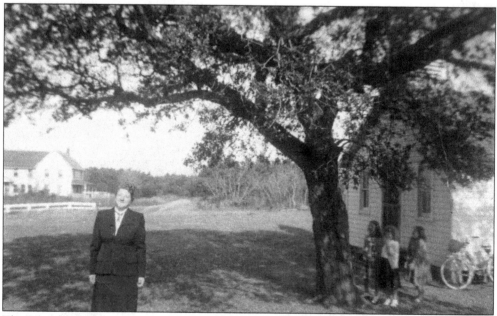

The Whalehead Club shut down after the sudden death of owner Ray Adams in 1957. The employees were let go, and only two students remained at the Corolla Schoolhouse. Currituck County closed the Corolla Schoolhouse doors permanently. For children to attend mainland school, parents either ferried them across the sound daily or boarded them for the week at mainland homes of friends and relatives. (Norris and Scott Austin.)

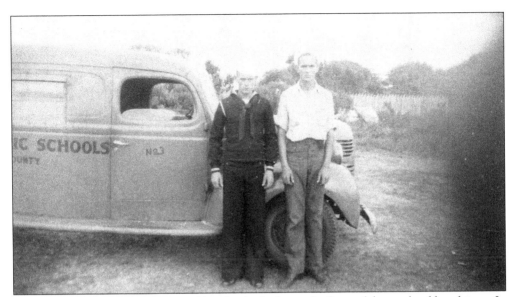

Cutting up on the bus was not a problem by the looks on the faces of these school bus drivers. In the 1980s and 1990s, parents and students made great sacrifices for education. Scott and Kathleen Austin temporarily moved to Kitty Hawk so their daughters could attend Dare County Schools. High school student Edward Ponton left Corolla for Manteo at 5:30 in the morning. His day included two two-hour bus rides. (OBCWE, Steven Meade Collection.)

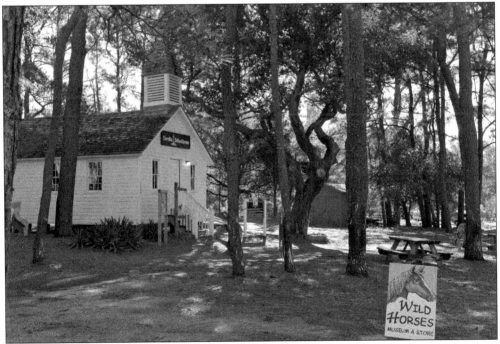

The Twiddy family has succeeded in the real estate business since 1978. Sharon Twiddy said, "Our children, grandchildren, and visitors deserve to have actual landmarks where they can get first-hand appreciation for Corolla's heritage." After the Twiddys renovated the Corolla Schoolhouse in 1999, the building was used temporarily as a wild horse exhibit. Today, the building is once again a school. (John Aylor.)

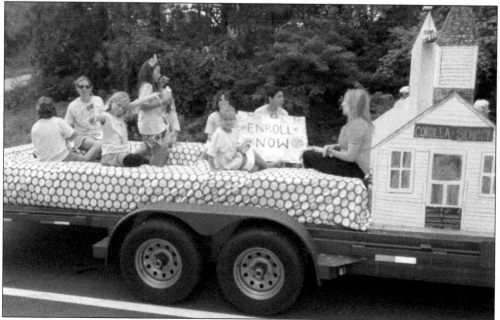

Two mothers who wanted a better education for all of Corolla's children started brainstorming ways to establish a school. Meghan Agresto, the site manager at Currituck Beach Lighthouse, and Sylvia Wolff, an employee of Corolla Fire and Rescue, researched the idea of a charter school. They promoted their cause in the Duck 2012 Fourth of July Parade. (Meghan Agresto.)

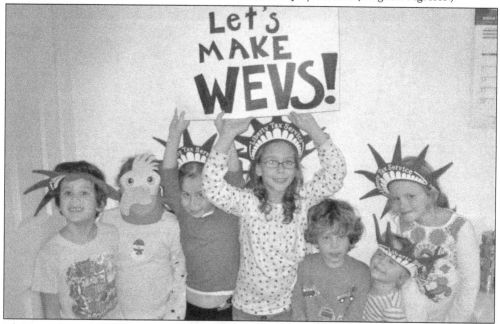

Choosing the name WEVS, Water's Edge Village School, was the first step in making application to the state. A charter school is a public school that is run independently of the county school board by a nonprofit organization. The state provided some funding, but additional revenue was needed. A "linguine for learning" dinner in 2010 was a fun moneymaker for these Pine Island kids. (Meghan Agresto.)

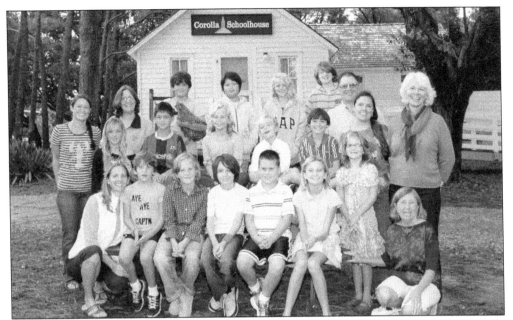

After being turned down several times by the state, approval was finally granted. The Corolla Educational Foundation had 10 months to write a student manual, select curricula, adopt a budget, hire teachers, and enroll students. The foundation secured the use of the old Corolla Schoolhouse for up for 20 students. WEVS started class on August 28, 2012, with respected elder Norris Austin ringing the school bell. (Lorenz Fine.)

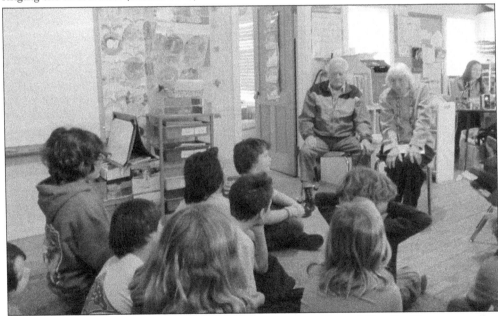

Meghan Agresto said that the school's wider campus is the village of Corolla. There are endless opportunities to study history and science with the close proximity of the Currituck Beach Lighthouse, Outer Banks Center for Wildlife Education, Whalehead Club, and Pine Island Audubon Sanctuary. Students received a visit by Suzanne Tate, the prolific author of children's nature books, and her husband, Billy Gray. (Meghan Agresto.)

One of Pell and Lela Austin's 11 children, Grace Meade (left, in 1951) returned to Corolla with her husband, Robert (right), and two sons every chance she got. It was too difficult to make a living on the Currituck Outer Banks, but working-class people from Virginia did make it their exclusive vacation spot. Old coupes were made into hot rods to rip up and down the highest sand dune. (Bobby Meade.)

Meade's parents gave her an acre lot adjacent to their village home. In 1960, the Meades used a bulldozer to pull this trailer along the beach from Sandbridge, Virginia, to the village of Corolla. They stayed here on weekends and for the summer. The city-raised Meade sons became avid hunting and fishing country boys. (Bobby Meade.)

Robert Meade (left) drove directly down the beach from Virginia to fish, unwind, and socialize, like so many others. Vehicles that got flooded by the tide or were rendered inoperable were abandoned on the beach and eventually covered by blowing sand. Meade's son Bobby once gunned his hot rod to get over a dune and ran smack-dab into the parked vehicle of police deputy Griggs O'Neal. (Bobby Meade.)

In 1959, a lack of plumbing and creature comforts at the family vacation home only added to the ambiance for the Scarboroughs. From left to right are Jim, Andrew, Andy, Lynn, Jewel, Elwood Parker, and Karen. These days, Karen and her husband, John, operate their gift shop, Spry Creek Boutique, out of the converted garage of that vacation home. (Karen Scarborough Whitfield.)

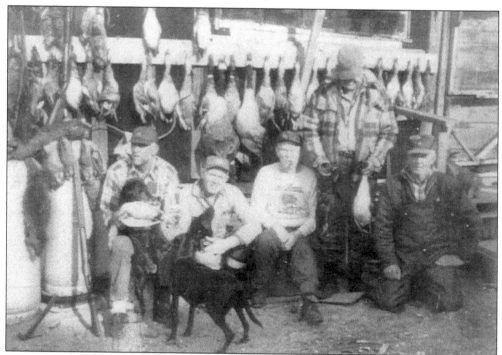

Roanoke Islanders at T's Camp near Penny Hill enjoyed hunting together. From left to right, they are Tedrick Tillett, Leland Tillett, Victor Daniels Sr., Earl Tillett, and Joe Dowdy. They also knew that there were other outdoor adventures. The flats and woods near Wash Woods were covered in small huckleberries. Gatherers had to endure the mosquitoes, flies, red bugs, and ticks to get their rewards. (Button Daniels.)

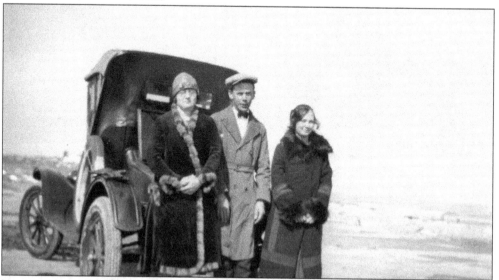

Virginia Austin (left) and friends felt the thrill of riding along the beach. When Steve Basnight Jr. was stationed across the Virginia border, one of his US Coast Guard duties was to drive south on patrol. One foggy night, he suddenly found himself in the midst of stumps uncovered in the wash. When he swerved to higher ground, he headed into a herd of wild hogs. He cried out, "Where am I? The Twilight Zone?" (Norris and Scott Austin.)

Seven

BIGGEST SANDBOX
IN THE WORLD

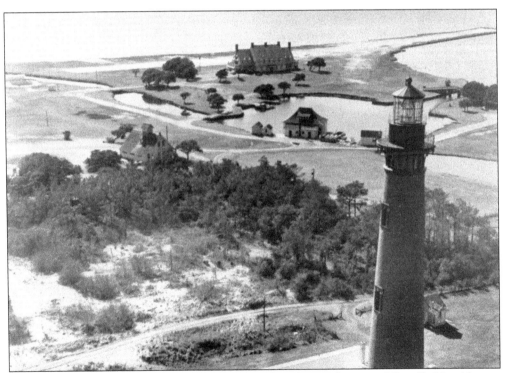

The Knights, whose creative vision was manifested in their sophisticated Corolla Island house, died within a few months of each other in 1936. Since their heirs had no interest in hunting, the residence was put up for sale. William Sirovich, a doctor, playwright, and congressman from New York, put in an offer of $175,000, but died on the day he was to close the transaction in 1939. (NPS, CHNS.)

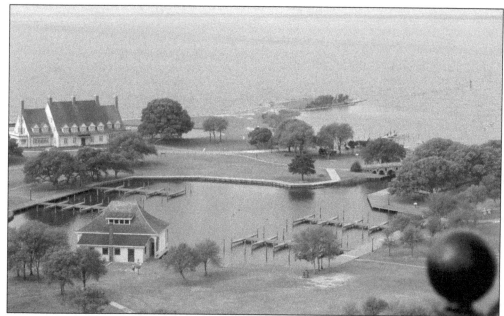

Corolla Island was constructed for $388,000 out of the finest materials. In contrast to wooden structures on the Outer Banks, the mansion had steel beams, masonry walls, a copper roof, brass pipes, cork floors, a basement, and a mahogany staircase. There was an elevator, a diesel generator for electricity, a huge boathouse, and duel plumbing with fresh well water for drinking and saltwater for healthful bathing. (John Aylor.)

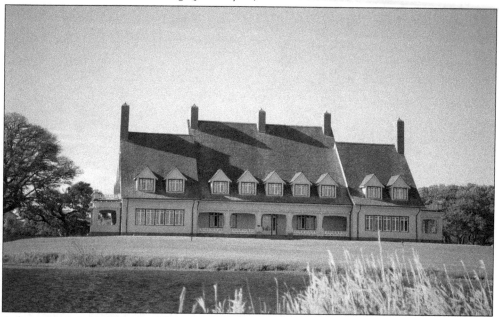

A decorative nature theme ran throughout the house. The signed and numbered Tiffany sconces had glass shades etched with water lilies. The doorknobs, handles, and hinges carried images of flora, fauna, and fowl. A handcrafted frieze of kissing swans surrounded the exterior. Today's real estate agent would think that this property, a work of art in a remote location, would take "the right buyer." (John Aylor.)

Instead of a real estate agent, US representative for North Carolina Lindsay Warren promoted the Corolla Island mansion in Washington, DC. His friend Ray Adams, a businessman with banking, railroad, realty, and meatpacking interests, made a shrewd offer of $25,000. In the 1950s, Ray Adams sat on the veranda with his buddy Earl Simons. (Joe Simons.)

Adams got a deal on the house, which came with approximately 2,000 acres and miles of sound front. For an additional dollar, he bought all of the effects left behind, which included silver, furniture, boats, and hunting gear. His wife, Eleanor, suggested they rename the property Whalehead Club. Large bony sections of what was presumed to be a whale's head had been unearthed there during the original construction of the house. (Joe Simons.)

Ray and Eleanor Adams hosted many appreciative friends. They advertised the club as an English hunting manor and provided accommodations for paying guests. Adams had a runway built for those who wanted to fly in. Club superintendent Dexter Snow, shown here, met other guests at the dock and brought them across the sound in his gas-powered boat. (OBCWE, Steven Meade Collection.)

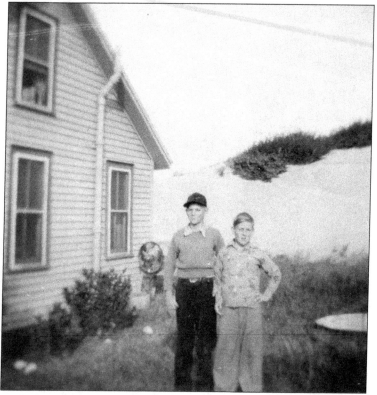

World War II brought about a pause to the revelry at the Whalehead Club. German U-boats were decimating vessels along North Carolina's coast, giving it a new nickname, "Torpedo Alley." Children, like O.W. (left) and Norris Austin (right), were no longer allowed to go to the beach unaccompanied. Parents knew there was a possibility that dead seamen had washed ashore. (Norris and Scott Austin.)

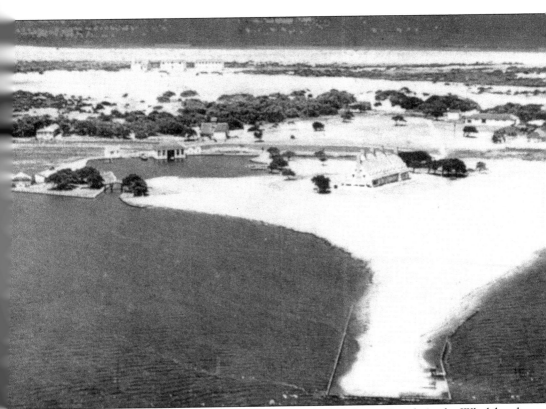

On August 6, 1942, Ray Adams leased his property to the US Coast Guard. At the Whalehead Club, the US Coast Guard made painting, electrical, plumbing, and heating repairs. The boat basin was dredged to its original depth of six feet. Barracks were positioned along the oceanfront, and the club became a station to receive hundreds of new US Navy trainees before their deployments. Life also changed dramatically for the villagers on the Currituck Outer Banks. Lights had to be blackened out to keep enemy submarines from using them as backlighting to target ships. The Currituck Beach Lifesaving Service Station (in this photograph, directly behind the boathouse) was reactivated so that surfmen could rescue merchantmen whose ships had been sunk. Beach patrols by foot and by horseback began again. This time, the guardsmen were armed with more than just flare pistols. They were looking for German spies and submarine conning towers. Horses were brought from the mainland and kept in stables constructed of materials from an abandoned US Civilian Conservation Corps camp. Hay was stored in the Currituck Lighthouse's Little Keepers' House. (Norris and Scott Austin.)

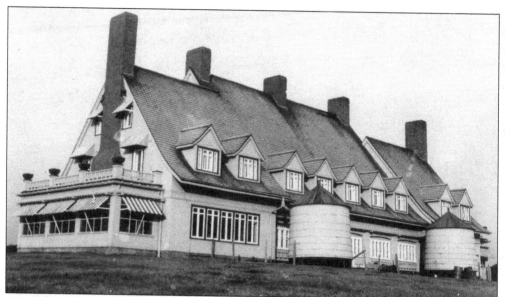

Large cisterns to catch and store water off the steep roof of the Whalehead Club were added during the World War II era. One seaman remembered singing with his pals around the Steinway & Sons grand piano, which had been specially made for Marie-Louise Knight. The same seaman recalled that military horses escaped and had to be herded up by enlisted men in jeeps. (OBCWE, Steven Meade Collection.)

At the close of the war, Ray Adams saw a spike in Virginia Beach's population and recognized that servicemen and their families would appreciate the serenity of Corolla. He lobbied for more than six years to bring about the construction of a scenic highway that would hug the coast from southeastern Virginia all they way to Nags Head, North Carolina. However, public funds went to other highway projects. (Joe Simons.)

Adams enjoyed the beach with family friend Joyce Springle Rabat. Efforts to bring about a 56-mile-long ocean highway with private funds under the turnpike law also failed for Adams. Undaunted, he used $2 million of his own money in the development of "Corolla City." He advertised it as "a multi-million dollar carefully controlled resort city for year 'round country club living." (Joe Simons.)

A parade of influential politicians and celebrities were received at the Whalehead Club. Adams brought in his personal secretary, Gin Leinneweber (third from left), to act as hostess, club manager, and treasurer of the corporate team to bring about Corolla City. This photograph shows the birthday celebration of Tex Leinneweber (second from left), Gin's husband. (The Whalehead Club.)

Ray Adams (right) first met Aydlett native Naomi Springle Simons (left) in 1943 when she waited on tables at the Croatan Inn in Kill Devil Hills. She and her husband, Joe Ray, and their sons moved into a small house on the Whalehead Club property. Naomi worked in the club and cared for a productive garden. Joe Ray did everything from guiding hunters to mowing the lawn. (Harry Harrington.)

Adams became good friends with the whole Springle family. Sisters Joyce, Naomi, and Mattie often worked, visited, or helped at the Whalehead Club. Adams invited Naomi and some of her family to Washington, DC, where he spared no expense in showing them around. Posing in front of Ray Adams's meatpacking business in the early 1950s are, from left to right, Earl Simons, Ray Adams, Harry Harrington, and Joe Ray Simons Jr. (Harry Harrington.)

Mattie Springle Harrington came to work at the Whalehead Club with her young son Harry while her husband was in the US Navy. She expertly cooked the geese and ducks the guests killed. In this photograph, she stood in front of the pink-tiled walls in the club kitchen. Of Ray Adams, Harry Harrington said, "I absolutely loved that man. He could not have been nicer to the kids." (Harry Harrington.)

Ray Midgett (left) and Harry Harrington (right) show off a stringer of freshwater bass. Ray Adams let nine-year-old Harrington drive a jeep to pick up newly arriving guests at the boat dock. The guests' eyes got as big as saucers when they saw their chauffeur. During the rest of their visit, Harrington drove them back and forth to the beach. He also took his younger cousins Earl and Joe for bouncy rides. (Harry Harrington.)

Harrington titled this photograph, "All a boy needs." He had his dog Blackie, a BB gun, and his own jeep. Harrington's father bought this well-used jeep and replaced the motor. When the school term began, he took Harrington across the sound to a dock where a bike was kept. Harrington rode a mile to the same school to learn under the same teacher that his mother had. (Harry Harrington.)

From left to right, Harry Harrington and his two cousins Earl and Joe Simons were allowed roam in a boy's paradise. Joe Simons referred to their domain as "the biggest sandbox in the world." They often found oranges, grapefruits, and whole stalks of bananas washed ashore from ships. Canisters of Army K-rations from World War II also washed up and contained cigarettes, chocolate bars, crackers, and powdered milk. (Harry Harrington.)

Beachcombing yielded US Army helmets, web belts, and, once, a live grenade. Joe and Earl Simons met prominent men who came to the Whalehead Club, although they may not have appreciated it at the time. The pilots who brought in guests and supplies on the small planes, however, did impress the boys. A kind pilot let Joe (left) and Earl (right) dream big for a moment in 1956. (Joe Simons.)

The only suspicious characters that Harry Harrington (left) and his buddies encountered were the men on the beach who tended horses to later sell. The unwashed and unshaven men were living one step above homelessness in tar paper and cardboard shacks, using fire barrels for warmth and tarpaulins for blankets. Waves of greeting were exchanged but never any talk. (Harry Harrington.)

Photojournalist Aycock Brown set up this photograph of, from left to right, Ray Adams and Earl, Joe, and Naomi Simons in front of the Whalehead Club footbridge at the boat basin entrance. Another shot from this series pictured the brothers standing on the bridge, and it appeared in an article about Corolla in the October 1955 edition of the *National Geographic* magazine. (Joe Simons, Aycock Brown Collection.)

The club owned two Chesapeake Bay retrievers, Curly and Queenie, shown here with Joe Ray Simons Sr. Curly, who truly lived up to his name, ran off local boys who wanted to traipse about on the property. Curly snatched up snakes and killed them while the Simons family walked along the sound shore looking for soft crabs. He did not slow down after being hit by an airplane propeller that cut off part of his jaw. (Joe Simons.)

Harry Harrington and his mild-mannered dog Trap had many adventures together. In *The Whalehead Club,* author Susan Joy Davis wrote about how Curly, the club's Chesapeake Bay retriever, did not let patrons swim past a certain fixed point in the ocean. He swam out to retrieve them whether they wanted to be "rescued" or not. Earl Simons had a similar experience when Curly grabbed him by the bathing suit waistband and hauled him to shore. (Harry Harrington.)

In 1954, Whalehead Club manager Gin Leinneweber recruited college students Barbara Rowland (left) and Carol Humphries (right) to work as housekeepers and waitresses. The people who spent their youth at the club said they could navigate through the big house blindfolded. The boys remember the smell of the fascinating gun room where they could look but never touch. (Joe Simons.)

Ray Adams sponsored families disenfranchised by World War II through the Lutheran Mission Society in Washington, DC. Hungarian immigrants Jacob and Margaret Kutschenko were given jobs and a place to live. Here, they stand under the Corolla pines with their twin boys, Udo and Uno. They also found a place to heal from wartime trauma since Corolla was a quiet, safe sanctuary of natural beauty. (Joe Simons.)

A refugee from Germany, Emil Eippert, suffered from a bayonet injury he received in World War II. Ray Adams arranged and paid for an operation that improved Eippert's quality of life. Eippert's daughter Meta wrote years later to Joe Simons, "You and your family, and Mr. Adams, made us feel so welcome, like we belonged in Corolla. You showed us that Americans could be kind and generous." (Joe Simons.)

German immigrant Emil Eippert's family, from left to right, Meta, Karl, and Rösle, came to the United States without knowing English. Meta remembered that she was expelled from the Corolla Schoolhouse because she could not speak English. Naomi Simons came to her aid. Under Simons's tutelage, Meta learned the basics and returned to the Corolla Schoolhouse in a reasonably short amount of time. (Joe Simons.)

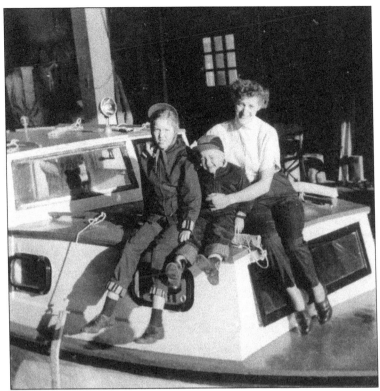

Meta Eippert recalled, "I remember the forts we built and the exploring we used to do in Corolla's untamed vegetation. I'll never forget the day we were exploring and came across a large water moccasin. You [Joe Simons] were our hero that day, acting so protectively." The neighborhood children played on the Simons family swing set. (Joe Simons.)

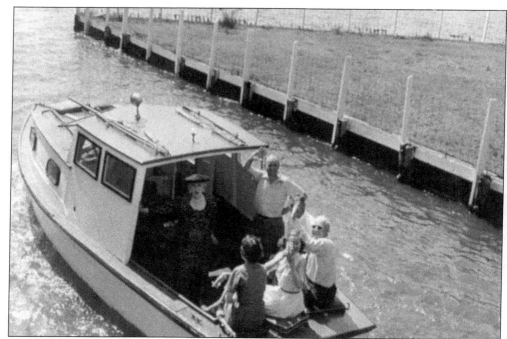

A boat of merrymakers passed under the footbridge. The day before Ray Adams died, the staff was keenly aware that he was not feeling well. Nevertheless, a feral pig had been shot, and Adams wanted to go ahead with plans to cook it outdoors. He could only sit and watch from his truck. Naomi Simons surmised that if he had to die, he wanted to die in Corolla. (OBCWE, Steven Meade Collection.)

Ray Adams died the last day of 1957. Employment and housing came to an abrupt end for the Simons family and other workers. The dream of Corolla City also came to an end. Grateful immigrants who became US citizens moved to other parts of the country. The children who lived at the Whalehead Club always remembered Adams's kind gestures, down to letting boys sit in on a Shriner photograph. (Joe Simons.)

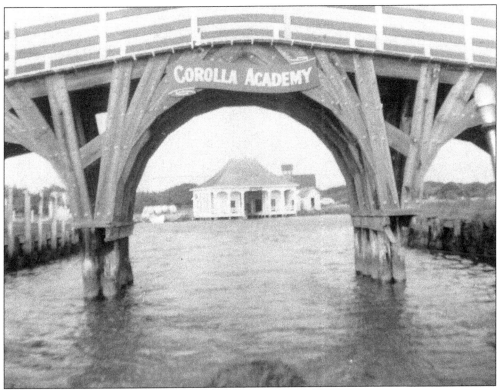

Eleanor Adams quickly sold the entire Whalehead Club estate to Virginians George McLean and William Witt for $375,000. Hatcher C. Williams, a friend of Witt, rented the property and established the Corolla Academy, a summer school for boys that also provided recreational activities. His postwar sentiment was the following: "The time has passed when American boys can afford to waste three months [of summer]." (OBCWE, Steven Meade Collection.)

Corolla Academy boys from all across the nation studied on the Whalehead Club porch, dined in an old lifesaving station, and slept in World War II barracks. Many students were dismayed by the brevity of the recreation period. Lonely boys made their way to the local store, where they could hear old hunting tales, enjoy a candy bar, and receive some grandfatherly compassion from John Austin (shown here). (Norris and Scott Austin.)

The Whalehead Club estate was again up for sale again. Corolla Academy had to relocate after just three summer sessions. Atlantic Research Corporation of Alexandria, Virginia, used the club and grounds to test the solid rocket propellant they were developing. Testing produced toxic residue that Outer Banks winds carried out to sea away from human populations. Here, caretaker Gene Austin checked a turbine. (The Whalehead Club.)

A bright flame glowed and a smoke plume billowed from a static test stand. Scientists and researchers slept and ate in the main house of the Whalehead Club. They played cards when there was no wind. Outbuildings were used to store and mix explosives and cast and assemble rocket parts. Atlantic Research was initially successful, but the decline of the space race brought about a natural end to the business venture. (The Whalehead Club.)

Eight

FROM ROAD TO REAL ESTATE EXPLOSION

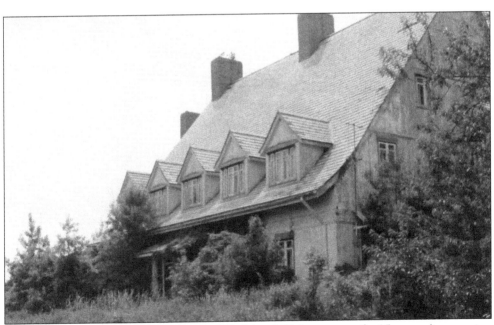

After Atlantic Research left Corolla, the Whalehead Club sat empty for 25 years. A succession of owners all had aspirations to bring it to life as a centerpiece lodge in a housing development. Each dream dissolved since there was no paved road to the Currituck Outer Banks. Corolla's population dwindled to just 15 in the early 1970s. Once again, the post office was in danger of being closed. (Buddy Ponton.)

Deputy Griggs O'Neal (left), the only law officer in Corolla, always had time to hunt with a friend. Mitchell and Doug Bateman (not pictured), who were teenagers in the 1970s, often took their skiff from Adylett to Corolla to go surfing. With surfboards in hand, they ran quickly through the Whalehead Club grounds because the starving mosquitos suddenly had victims. (Norris and Scott Austin.)

Residents and occasional day-trippers to Corolla took their own tours of the Currituck Beach Lighthouse. The Bateman brothers would slip through the rotten door and climb the deserted tower like "a bunch of monkeys." The Whalehead Club was eerily intact although many artifacts, including the Tiffany sconces, had been taken. Edward Ponton (shown here) sat at Marie-Louise Knight's Steinway. (Buddy Ponton.)

Edward and Annie Ponton stood before an intricately carved sideboard concealing a safe, a piece from the original Whalehead Club furnishings. In 1991, the Currituck Wildlife Guild petitioned Currituck County to buy the Whalehead Club to make it into a wildlife heritage museum. Beach tourism began to increase at this time, and the county was in a position to buy the Whalehead Club thanks to a newly instated occupancy tax on seasonal lodging. (Buddy Ponton.)

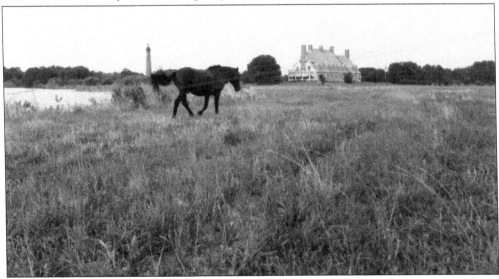

Currituck County purchased the Whalehead Club and 28 acres for $2.5 million in 1992. That was just the beginning of expenditures. The county committed nearly $5 million more for a restoration faithful to the original 1925 standard. The residence itself became the focal point of the museum. Tours showcase the opulence of the mansion, and the Whalehead grounds became a public park. (Buddy Ponton.)

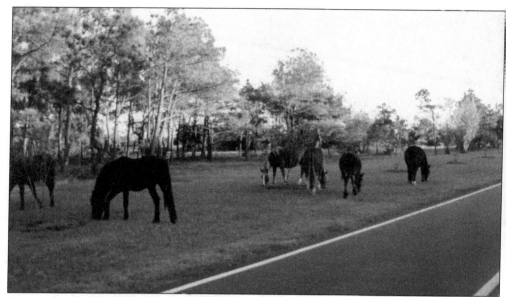

The idea of keeping Corolla exclusive was taken to the extreme as landowners north of Duck at Ocean Sands Development built a guard shack to keep the public from driving through their land. Many Corolla residents felt that they were being held hostage between two heavily guarded gates, the south gate at Ocean Sands Development and the north at Back Bay National Wildlife Refuge in Virginia Beach, Virginia. (Fran Mancuso.)

Barry Nelms was the typical Outer Banker in that he had more than one job. After a long day of teaching marine biology at Currituck High School, he rushed to the houses he was building at Currituck Beach. He built the first house (shown here) in 1981 in the Whalehead subdivision. Development and his construction business could not grow until a public road was paved. That finally happened in 1984. (Kelly Nelms Shelton.)

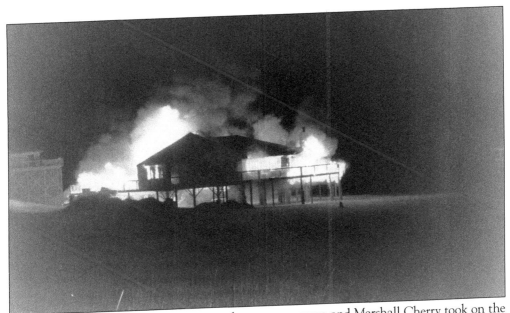

As home building increased, a fire station became necessary, and Marshall Cherry took on the position of fire chief. He and Barry Nelms formed a bond after they both lost young sons in heartbreaking circumstances. Their tragedies were a catalyst in the establishment of an EMT squad. Both men served as county commissioners to ensure the growing community of the Currituck Outer Banks received emergency services. (Corolla Fire and Rescue.)

Contractor Bernie Mancuso (right) experienced gains and losses in the luxury home-building business. Mancuso got his break when a dissatisfied investor told then carpenter Mancuso if he got his contractor's license, the investor would turn over a housing development to him. Mancuso and other citizens always contributed to the community, adding a bay to the Whalehead Fire Station in the early 1990s. (Corolla Fire and Rescue.)

Pro-active Marshall Cherry recruited students who were on college swimming teams to come to Corolla for the summer as ocean-rescue lifeguards. When the state passed a law to fund emergency 911 services, Cherry used his engineering background to devise a new and logical system of assigning addresses on the Currituck Outer Banks that was based on miles away from the Dare County line. (Corolla Fire and Rescue.)

Annie Ponton unlocked the state line gate when returning to Corolla from Virginia. She traveled the road that skirts Back Bay National Wildlife Refuge, cutting miles and hours off her trip. A select few locals hold permits to use this convenient but highly restricted roadway. When her husband, Buddy, passes away, the Ponton family suspects that their permit will be cancelled for good. (Edward Ponton.)

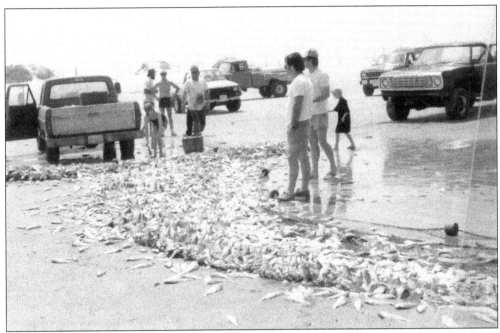

An acquaintance of Buddy Ponton wryly remarked that Ponton ran his fishing outfit with "hippies and druggies." Ponton did hire people on the fringes of society, but he worked them hard and paid them a generous share. His livelihood has come to an end as a result of stricter fishing regulations and an influx of new homeowners who do not tolerate commercial beach fishing. (Buddy Ponton.)

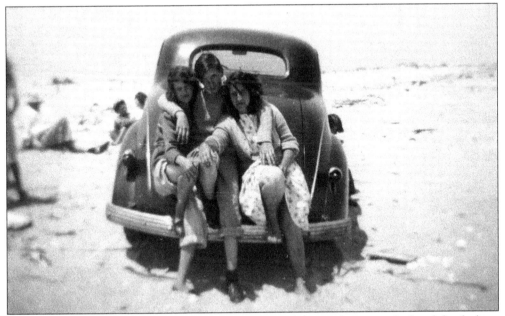

In the days before four-wheel drive vehicles, any automobile was driven on the beach by slacking the air out of tires. Until recently, tourists visited Corolla in the warmer months. Year-round residents looked forward to the slower pace of the off-season. Edward Ponton, brand ambassador at Twiddy and Company Realtors, now trains staff to think in terms of being busy all year long. (Norris and Scott Austin.)

During an average summer, an additional workforce of 300 international students comes to clean houses and work restaurant and retail jobs. This ethnically diverse group of young people gathered at the steps of the Corolla Chapel in 2019 just after reporting for duty. The church family will show them love by treating them to weekly dinners, karaoke and game nights, and trips to local sites of interest. (Edward Ponton.)

Many believe that a seven-mile mid–Currituck County bridge will be built as a quicker route to Corolla. Plans to finance the $600 million expenditure are dependent on charging a very steep toll to cross it. Opponents, who have put up this billboard, call the bridge fiscally irresponsible and environmentally harmful. Some residents and visitors are afraid of losing that sense of leaving civilization and getting away from it all. (RWG.)

Some native Currituck Outer Bankers fear that rapid growth of the area will result in the loss of free-spirited characters, like Jewel Scarborough (shown here). Another character, Carova resident Marlene Slate, stopped her car next to strangers hitting golf balls into the ocean. They expected a dressing down from the venerable lady. Instead, she grabbed her clubs from the trunk and joined them. (Karen Scarborough Whitfield.)

In 1989, Leland Tillett leaned on an oak in front of the "camp" he built for less than $100 near Pennys Hill. He waited for winter storms that brought lumber and debris to construct the tiny house. Tillett would be astounded to see modern-day homes that feature lazy river swimming pools, gyms, movie theaters, industrial kitchens, and a bathroom for each bedroom. (OBHC, Drew Wilson Collection.)

The southeast view from one of the Currituck Beach Lighthouse's galley decks reveals just how much construction has taken place near Corolla in the last decades. Today, public services are better than ever on the Currituck Outer Banks, but residents still must do without many cultural, educational, and medical advantages. (Edward Ponton.)

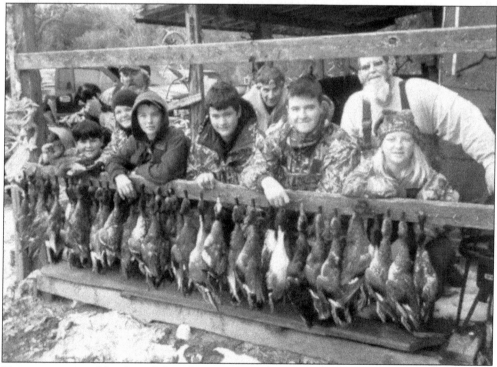

Two generations of family and friends enjoyed a successful hunt on land held in a family trust. This camp, called Dough's Den, is closer to the million-dollar oceanfront than one would imagine. From left to right are (first row) Sam Dough, Ben Brown, Tucker Stetson, Vance Daniels, Nathaniel Cahoon, and Darren Saunders; (second row) Macon Dough, Woody Stetson, and Gaston Saunders. (Button Daniels.)

Emil and Rösle Eippert, German immigrants who came with their young son and daughter to Corolla after World War II, returned to a place of refuge. This photograph shows them seated in Adirondack chairs with their expanded family in the 1990s. They saw Corolla change tremendously in their lifetime, but they were drawn back to a place of natural beauty and serenity. (Joe Simons.)

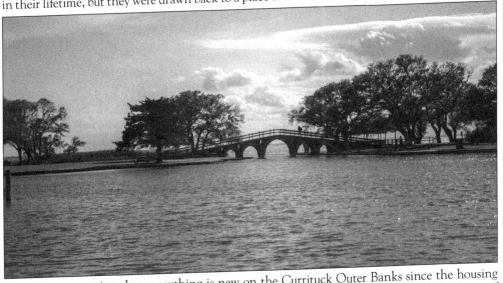

There is a perception that everything is new on the Currituck Outer Banks since the housing developments are well planned and recently built. Nevertheless, Corolla does have a rich history of people with ingenuity, grit, and compassion. They were lifesaving servicemen, lighthouse keepers, and villagers who came to the aid of shipwreck survivors. They were fishermen, commercial hunters, guides, and cowboys. They were self-sufficient souls with a humility and faith inspired by a beautiful and harsh landscape. Most importantly, they adapted. And the local community today has adapted to new circumstances. They welcome those who respect Corolla's connection to the past. (Francesca Beatrice Marie.)

Visit us at
arcadiapublishing.com

Printed in the USA
CPSIA information can be obtained
at www.ICGtesting.com
LVHW051242261023
761548LV00010B/75